This book should be returned to any Lancashire County Council Library on or before the date shown

0 3 NOV 2021

0 4 MAR 2022

1 5 NOV 2022

2 3 NOV 2022

D1425793

3011814179959 7

ABOUT THE AUTHOR

Keith Johnson is Preston born and bred. His previous works include the bestselling 'Chilling True Tales' series of books featuring Preston, Lancashire and London. He also wrote the popular *People of Old Preston, Preston Remembered, Preston Through Time, Preston in the 1960s, Secret Preston, Preston in 50 Buildings, Preston History Tour, Preston at Work* and *A-Z of Preston* books. For over a decade he has contributed numerous feature articles on local history to the *Lancashire Post*, and since 2011 has written a weekly Court Archive for the *LEP Retro* magazine.

Keith was educated at St Augustine's Boys' School in Preston prior to attending the Harris College where he gained his qualifications for a career in engineering, before spending forty years working for the printing press manufacturer Goss.

First published 2018

Amberley Publishing
The Hill, Stroud, Gloucestershire, GL5 4EP
www.amberley-books.com

Copyright © Keith Johnson, 2018

The right of Keith Johnson to be identified as the Author of this work has been asserted in accordance with the Copyrights, Designs and Patents Act 1988.

ISBN 978 1 4456 7420 9 (print)
ISBN 978 1 4456 7421 6 (ebook)

British Library Cataloguing in Publication Data.
A catalogue record for this book is available from the British Library.

Origination by Amberley Publishing.
Printed in Great Britain.

CONTENTS

Introduction	4
Transformation	6
Transportation	22
Glorious Guild	40
Leisure & Pleasure	47
Sporting Life	67
Eighties Reflections	73
Acknowledgements	96

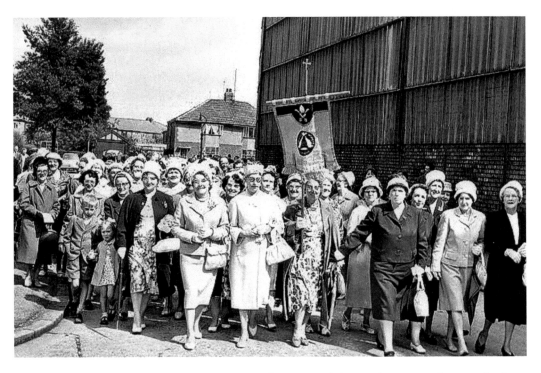

The Roman Catholics of Preston attended a rally at Deepdale in July 1961 to honour the forty martyrs of England and Wales. Over 21,000 packed into the PNE football stadium. These ladies can be seen happily making their way to the event, passing the old Spion Kop stand to the right.

INTRODUCTION

This book takes a look at three defining decades, from the dawn of 1960 to the end of the 1980s, that helped to shape the Preston of today. It was a period that began in the midst of redevelopment with slum clearance and home building well underway. Social attitudes were changing and great strides were being taken in industry, commerce, education and the retail trade.

It was a time for transformation, with old buildings bulldozed into oblivion and new structures standing tall. The Victorian Town Hall, the old Ribble bus station, an old church or two, old alehouses, many a corner shop and endless rows of cobbled streets were being swept away in the name of progress. Talk of high-rise apartments, office blocks and sprawling shopping centres filled the air and then became a reality. It was a period when traffic-free zones, ring roads and motorways were planned and came to fruition, while the transportation of people and goods came on in leaps and bounds on road and rail.

Throughout the 'swinging sixties' Preston was striving towards a glorious guild celebration that would reflect the attitude of the positive, proud people of Preston. That event kept the ancient traditions alive with pomp, pageantry and processions, and provided its fair share of fun and frolics.

The increase in leisure time made the pursuit of pleasure more intense. For some the discotheque took preference over the dance hall and public houses could no longer provide just beer and skittles. Some old and familiar places of entertainment were disappearing, while others emerged to fill the void. The sporting scene was changing too, with many inclined to participate rather than merely spectate and consequently the leisure centre and running track became fashionable.

Taking a peep at the endeavours of the eighties gives us a chance to recall the transport and the traffic, the markets and their merchandise, the carnivals and the concerts, the road runners and Red Rose Radio, cinemas and bingo halls, public houses and pub lunches, and the people on our streets. There is a patchwork quilt of pictorial memories within these pages and hopefully every picture will truly tell a story that you will find interesting.

I was delighted to be asked to write this book and take the opportunity to reflect on life in Preston throughout the three decades that I lived and worked through and recall with fondness. In conclusion, reflecting on Preston during those thirty years, it was a place populated with people full of pride who left a rich legacy for future generations. It was a place that learnt lessons from the past to make a brighter future, and a place that expanded rapidly yet still retained its parks and places of pleasure, embracing the evolution in industry, retail and education, ensuring employment for many. Its people held onto their traditions yet always looked to the future – being innovating, yet sensitive. Long may Preston prosper, remain rightly proud and be cherished by its inhabitants – young and old alike.

Times were changing, as this picture postcard of 1973 shows. The Market Square, Lancaster Road, Friargate and the old Bambers Yard area were being suitably transformed.

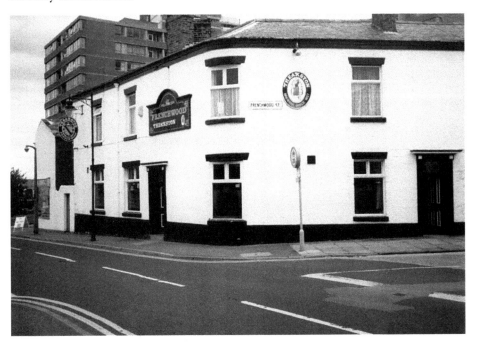

The Frenchwood Tavern on Avenham Lane, pictured in 1988, dates back to *c.* 1837. It was one of the many Matthew Brown public houses in the town, although by 1988 it was serving Theakston's beers. On the skyline the high-rise apartments built in the 1960s that transformed the Avenham area can be seen. The public house closed in 2003, then spent some time as a curry house, but is now a residential property.

TRANSFORMATION

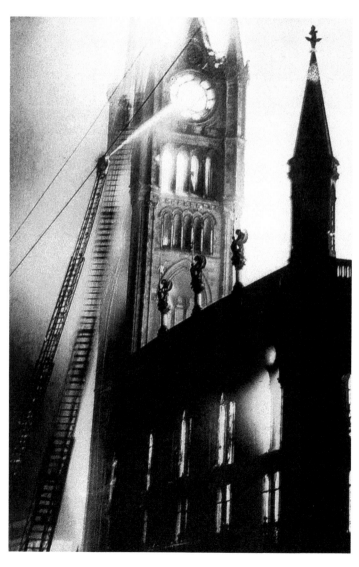

From the dying embers of the spectacular Town Hall fire of 1947 came the spark that eventually brought about a transformation of post-war Preston in the 1960s. Although it took fifteen years to remove that particularly burnt out eyesore, the town strode forward on the shopping and housing fronts during a period of prosperity. High-rise apartments, a spectacular shopping centre and a controversial ring road were all built. Love them or loathe them the changes had to be carried out and builders and bulldozers got busy.

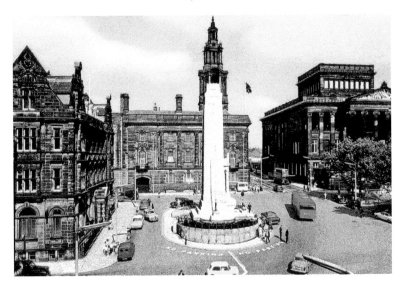

At the dawn of the 1960s the Preston Cenotaph, with its tapered column and stone tableau of grieving victory unveiled in 1925 to honour the 2,000 local men who perished in the First World War, holds pride of place in front of the General Post Office opened in 1903. The GPO, the Preston Sessions House in the background and the Harris Museum & Library building to the right are in need of a clean after decades of grit and grime – a legacy of the industrial age. Parking restrictions were beginning to take shape as the 'No Parking signs' show.

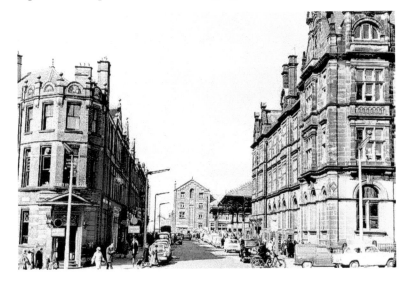

This view from Friargate in 1960 shows a busy Market Street with Martin's Bank occupying the old George Hotel premises on the left and the General Post Office to the right. Alongside the GPO stands a row of red telephone boxes that appeared first in the 1930s. Further on are the canopies of the Fish Market and Covered Market. In the distance on Liverpool Street stands a warehouse building known as Orchard Mill, where regular auction sales of antiques and furniture were held.

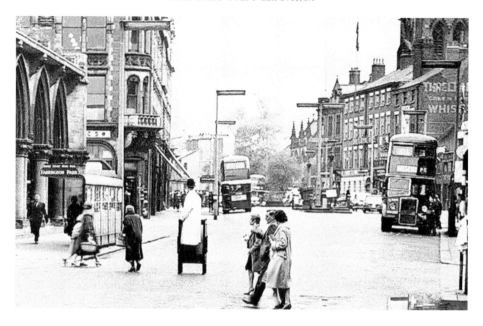

A view looking down Church Street in 1960 shows a policeman on point duty directing traffic. To the left, in front of the fire-damaged Town Hall that was awaiting its fate, was the Farringdon Park bus stop and further along Miller Arcade was open for business. To the right a Preston Corporation bus on the Hutton P5 route collects passengers.

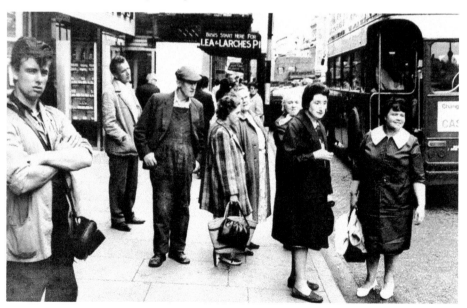

Rush hour and workers, shoppers and a bus conductor wait by the Lea & Larches P1 bus stop outside the Gaumont cinema, later the Odeon, on Church Street in 1961. Bus stops and shelters dotted around town were the order of the day before the central bus station was built.

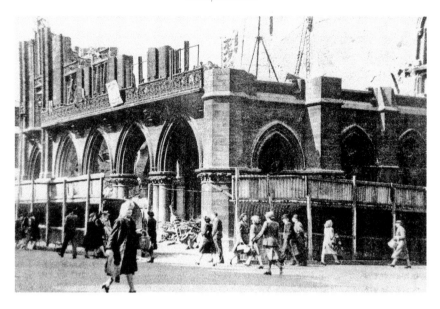

Across the road work is underway in 1961 on the demolition of the burnt-out Victorian Town Hall building. After years of wrangling over the fate of the building, with its clock tower at 176 feet tall and a weathervane that added another 15 feet, the fire of November 1947 had eventually sounded the death knell to the building opened in September 1867 amid great fanfare. Deep foundations were needed in a clay and sandy area, as had been necessary for erecting the Miller Arcade.

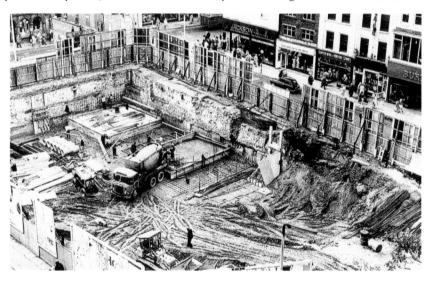

Workers are busy on the site of the old Town Hall in October 1962 as the Market Square is prepared for the construction of Crystal House. Shoppers on Fishergate pass the popular premises of E. H. Booths and further along Barratts and Freeman Hardy Willis have boots and shoes on offer. On Cheapside both Jackson and Burton are offering attire for gentlemen and the Scotch Wool & Hosiery Store tempts the ladies.

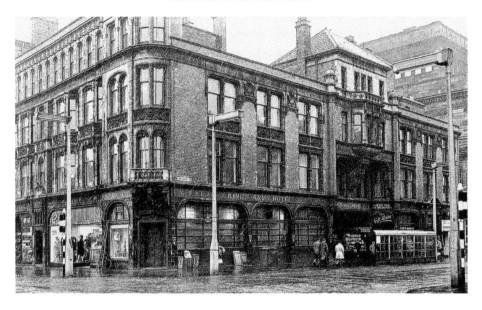

Miller Arcade on a rainy day in 1962 with the once familiar Kings Arms Hotel on the corner of Lancaster Road. It was the final days of a popular public house, called the 'Long Bar' by locals, that had among its landlords Hughie O'Donnell, the former Preston North End FA Cup-winning left winger of 1938. This shopping arcade, opened in 1899, was acquired by the Arndale Property Trust in 1946 and was known as Arndale House until 1972.

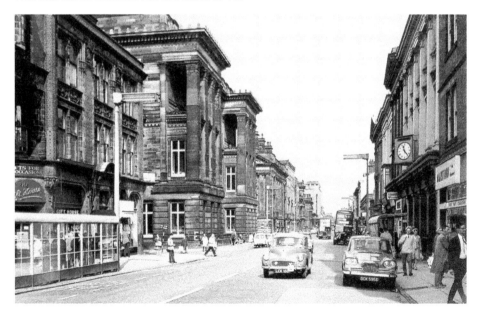

Looking down Lancaster Road in 1962 the Miller Arcade, Harris Museum and Preston Sessions buildings can be seen to the left, all displaying a blackened, grimy exterior in need of a clean. A learner driver is at the front of the late morning traffic with Preston Corporation and Ribble buses following behind.

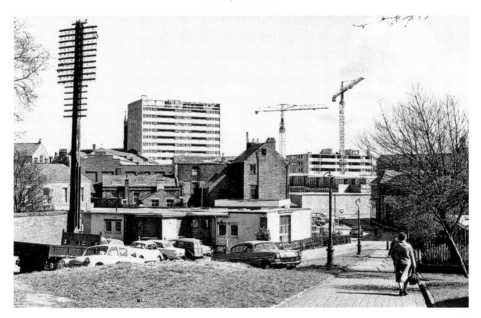

A lady strolls down Stoneygate in 1964. To her left was the First Church of Christ Scientist, established in Preston in 1905 – in 1950 they moved into their newly built permanent home. Tall cranes stand out on the skyline as the Avenham high-rise apartments take shape. Almost hidden from view is the tall tower of St Saviour's Church, which was closed in 1970 prior to demolition.

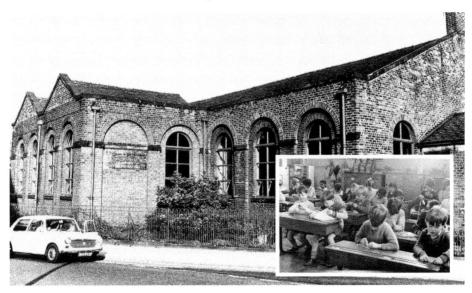

At the bottom of Stoneygate on Avenham Lane stood the National School, known later as the St John's Parish School. It was built in 1814, the same year as St Wilfrid's Catholic School in Fox Street. The Preston Savings Bank began their business within the school building in 1816. *Inset:* It's 1967 and the pupils of the National School are busy at work in the days of reading, writing, arithmetic and religious instruction.

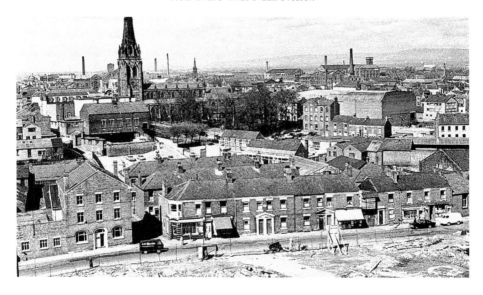

Avenham was probably the most affected area, besides the town centre, during the slum clearance period. In the foreground of this *c*. 1962 image work is underway in Avenham Lane on the construction of the tower block to be named Sandown Court, which stands 150 feet tall and was completed in 1965. Among the shops and houses of the terraced row was the Star bookshop, a popular store for comics, jokes and curios. Church spires, warehouse buildings and tall chimneys dominate the skyline.

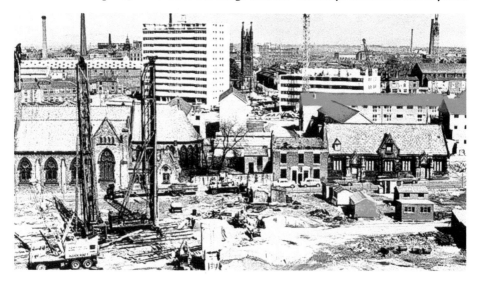

This view of Avenham in 1962 reflects the progress as slum clearance gives way to redevelopment with tall cranes on the skyline and high-rise apartment blocks towering ever upwards. The Church of St James, to the left, and St Saviour's, centrally placed, were still on view but not for much longer. Unfortunately, in the late 1970s examination of St James', opened in 1838, exposed dry rot and porous stonework leading to the eventual demolition of church and tower in 1983. Services were transferred to the parish hall.

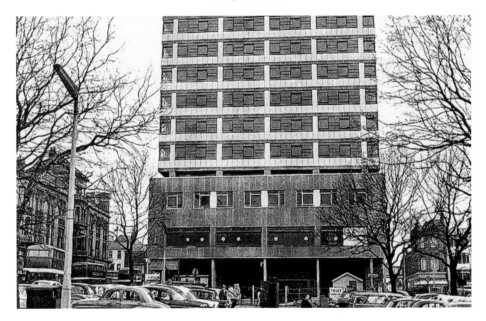

This view of the Market Square shows Crystal House in the final stages of construction in 1964. Soon the 164-foot-tall block of Crystal House with shop and office space would be complete. Take-up was slow, much to the disappointment of the Calgary and Edmonton Land Co., who had invested heavily in the venture, although eventually popular retailers would flourish there. Nowadays, it is known as the Cubic after a 2008 facelift that cost £4 million and raised its height to 200 feet.

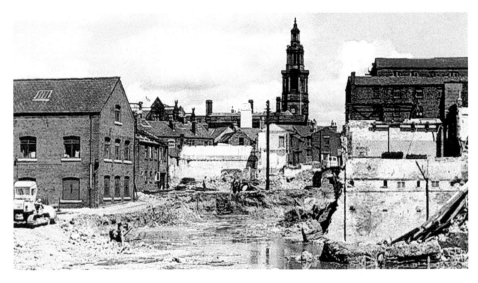

Just a stone's throw from the Market Square, the Bamber's Yard area was undergoing transformation in 1963 after an agreement was reached to build the St George's Shopping Centre. It meant farewell to a number of familiar premises that had occupied the ginnels and alleyways. As far back as 1869 the likes of Berry the cobbler, Crook the tea dealer, Petty the blacksmith and Bamber the cooper had plied their trade here.

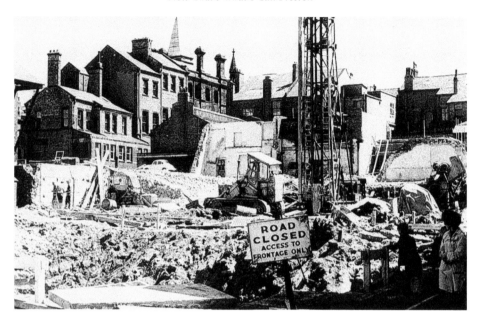

At the rear of Fishergate, Friargate and Lune Street the bulldozers were busy and chaos reigned, attracting the curiosity of young and old alike. Work was well underway in 1963 to create the St George's Shopping Centre. Not since the days when Nathaniel Miller built the Miller Arcade had Preston seen anything like this as St George's Shopping Centre took shape.

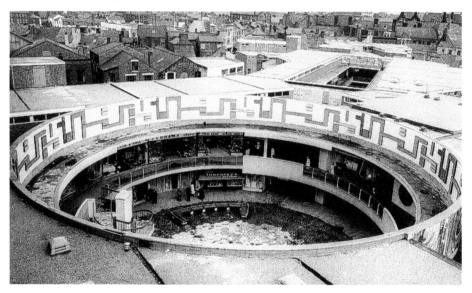

Soon the rotunda of the St George's Shopping Centre would appear and as this image shows the construction workers had quite a view over Preston. The centre was opened on the third Friday of November 1964 with some thirty of the 120 shops and kiosks ready for business. Construction workers were still busy on site working around the clock to complete the project undertaken by Murrayfield Real Estate Co.

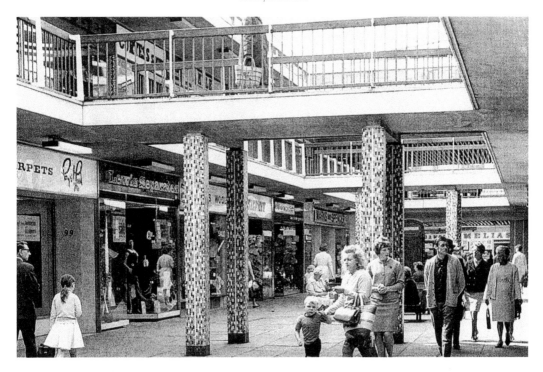

The novelty of shopping in a traffic-free environment pleased many early visitors to St George's Shopping Centre, who remarked on the attractive shops, the spiral staircases and the colourful mosaics. Among the familiar retailers were Cyril Lord carpets, Curtess shoes, Lewis Separates – with fashion from London – and Melia, the grocers where potted meat was a speciality.

Certainly, town centre shopping was as popular as ever, as this 1965 Fishergate view shows. Despite a drizzly damp day the shoppers were out in force. It could have been my mum, or yours, with her proper shopping bag or basket before the plastic carrier bags revolution took over. British Home Stores, Boots the chemist and Woolworths are all among the retailers on the left-hand side of the picture.

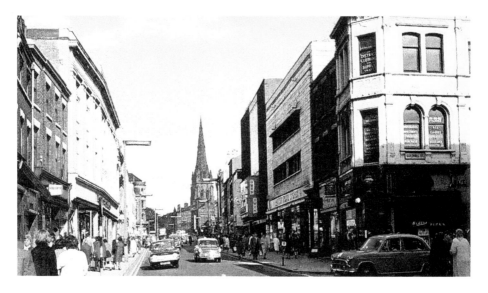

A sunny shopping day on Fishergate in 1966 with plenty on offer. To the right on the corner of Guildhall Street the 'House of Bewley' offers cigarettes, tobacco and pipes of every description. The modern-looking Owen Owen store, just past British Home Stores, had four floors and fifty departments full of tempting household bargains following their redevelopment in 1960. Across the road Marks & Spencer were flourishing with an entrance into St George's Shopping Centre on the ground floor.

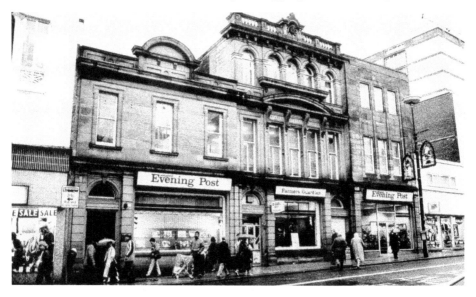

Also on Fishergate this familiar frontage is home to *the Lancashire Evening Post* and the *Farmers Guardian*. By this time the kiosk where people queued for the 'Last Football' on a Saturday night had gone. Behind the scenes was Castle Yard and the great printing press works often supplied with presses from local manufacturers Goss. The towering Crystal House can be seen at the top right of the image in its Market Square home.

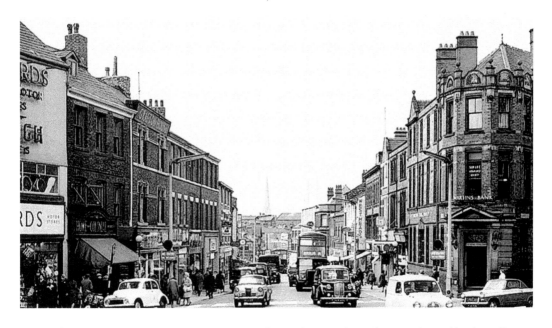

This *c*. 1964 image shows Friargate from the Market Place with Halfords, offering everything a cyclist could need, on the left next door to the Home & Colonial, a popular grocery store chain of the period. By this time a one-way system for traffic is in operation with vehicle 'No Entry' signs displayed. To the right is the sign of Westheads furniture and carpet business, which was started by John Westhead in 1845.

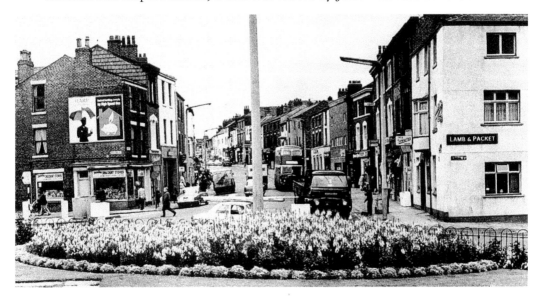

Friargate viewed from the Fylde Street roundabout *c*. 1965. On the corner of Walker Street is the Jumbo Discount Store were many a bargain was to be had, be it an electrical socket or a transistor radio. To the right on the corner of Kendal Street stands the Lamb & Packet public house displaying the Thwaites brewery sign. This inn has its origins in the early canal days when packet boats ventured to Kendal.

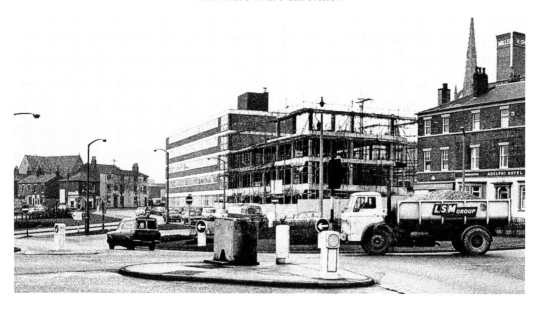

The Fylde Street roundabout, viewed in January 1969, shows construction work in progress on the second phase of the four-storey blocks that would house the National Insurance offices, part of the Ministry of Social Security. The buildings, known later as Casper & Robin House, were eventually purchased by UCLAN and knocked down in 2015 as the university campus was extended.

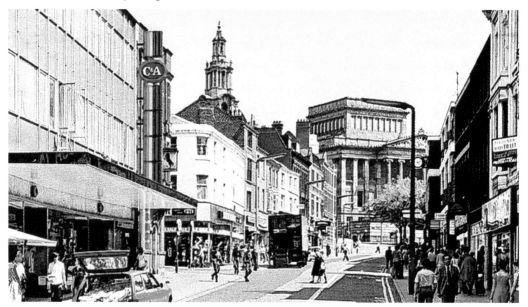

On Friargate in 1966 the arrival of clothing supplier C & A Modes on the site of the old Royal Hippodrome theatre was greeted with much excitement. Despite the appearance of double yellow lines on both sides of the highway, introduced by Transport Minister Ernest Marples in 1960, an estate car stops to load up. C & A Modes closed their entire UK operation in June 2000 and these days Wilko occupies the site.

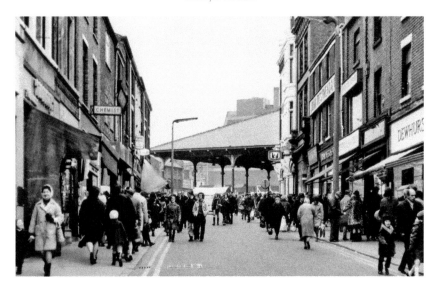

There is no doubting the popularity of Orchard Street in the 1960s, as these images from *c.* 1967 show. On a chilly Saturday afternoon the shoppers are well wrapped up in this view looking towards the Covered Market where Colley's Orchard once stood. At the dawn of the 1960s proprietors included Hunter, the gentlemen's outfitters; Cable Shoes; Westhead's, the furnishers; Scanlan, the jewellers; Goodwin, the hairdressers; and Wiggans, the confectioner.

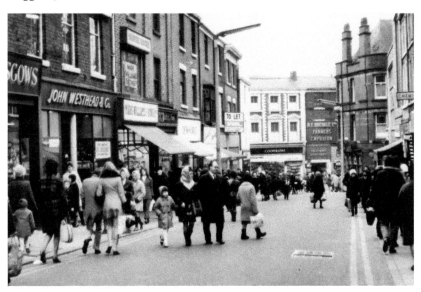

In this image looking down Orchard Street to Friargate, where the Co-operative Chemists stood, there are three butcher's shops on the left all in a row. The names of Mark Williams, T. C. Rainford and Dewhurst had become well established in the town and flourished for decades. Only with the spread of foot-and-mouth disease in 2001, coupled with a rise in supermarket meat, did trade dwindle for the traditional Preston butchers.

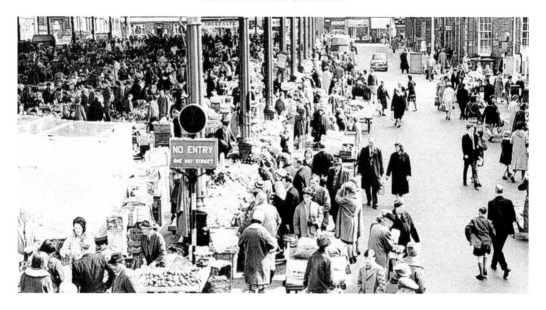

The Preston Covered Market in 1960 was a busy, bustling place, as this view up Earl Street shows. Fruit and vegetables were happily displayed beneath the outdoor canopy with sacks of spuds, parsnips and carrots ready to be weighed and dispatched. Gentlemen in suits and trilby hats were the height of fashion, as were ladies wearing longer skirts and coats. To the right the Earl Street police station was vacated in 1973 when the police moved to a new HQ on Lawson Street, which cost £600,000.

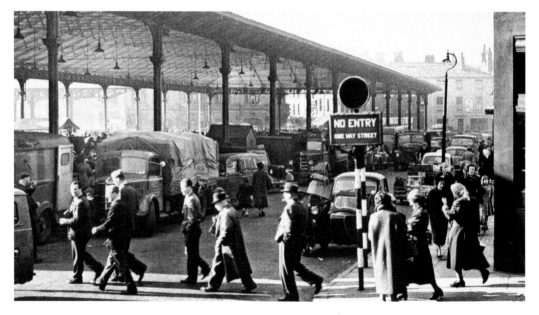

This view of the Covered Market from Liverpool Street reflects a scene that was about to change. A number of traditional market wholesale suppliers of fruit and vegetables had their premises facing onto the market. When the new Market Hall arrived they switched to a purpose-built site for wholesalers on Bow Lane.

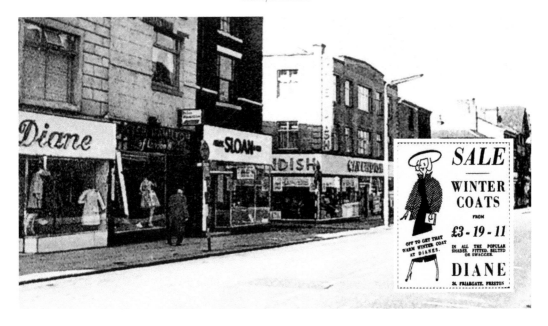

Things were about to change along Friargate as the Ringway development got underway. The later stages of the Inner Ring Road development involved the demolition of this row of shops on Friargate and others on Lune Street. Fashion stores Diane, Peter Hamilton and Sloan were among them along with the Cavendish furnishings store. *Inset:* Sale time at Diane's.

Causing much interest in the town centre was the first stage of the Inner Ring Road, stretching from Church Street along Park Road and through the old High Street and Starchhouse Square area before crossing Friargate to Lune Street. Mayor Joseph Holden moved the first shovel full of rubble with a mechanical digger in September 1966 for the £1 million development. Two years later the first cars were permitted to travel along it as cautious pedestrians stood around.

TRANSPORTATION

Great strides were made in road and rail transportation in Preston and beyond in the 1960s–80s. Having been blessed with the first stretch of motorway being built on its boundaries, Preston embraced further progress with more miles of motorway and link roads soon following. The age of service stations, flyovers and motorway junctions was upon us. An award-winning bus station soon followed, as did an upgraded railway system, as the cherished steam engines gave way to diesel and electrical power. Preston Docks were rarely out of the spotlight and for a while they seemed to have a bright future. Unfortunately, despite having years where they provided ferry and container transport and a capability of dealing with heavy haulage, the tide turned against them and they slumped into decline.

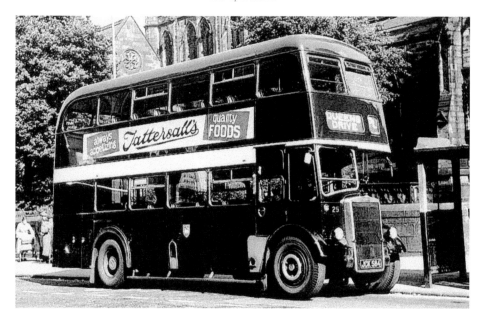

With no central location for local buses this Leyland Titan bus waits outside the Preston Parish Church on Church Street showing its intended destination – Queens Drive in Fulwood. In service as part of the Preston Corporation fleet from 1956, it was painted maroon and eventually withdrawn in 1969.

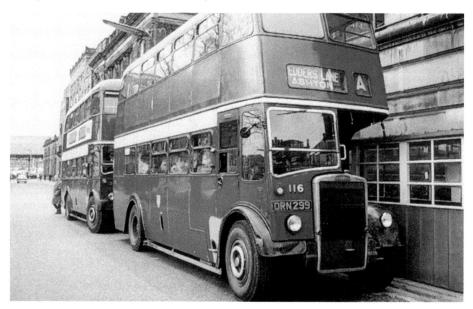

Preston Corporation buses, with their maroon livery, wait alongside the Harris Museum in 1967. The first bus is destined for Pedders Lane in Ashton, a popular route. Debate was going on at the time regarding the colour with the 'drab maroon' to be replaced by 'bright blue' according to Town Hall chiefs, who claimed it would save costs.

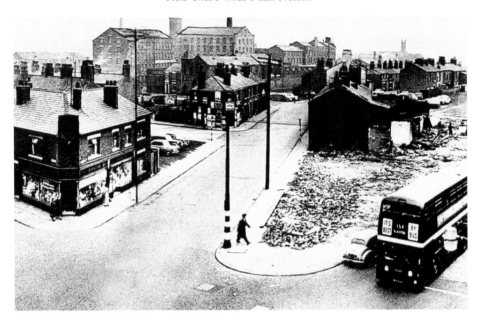

The clamour for a central bus station increased and this image, photographed from the top of the Hesketh Building on Ormskirk Road in 1964, shows the site earmarked for development. Dover Street, Alfred Street and the old Spring Gardens can be seen to the left as a Ribble bus emerges from Tithebarn Street to join North Road.

Dover Street, between North Road and Park Road, was developed in the 1870s, and was one of the streets destined for demolition in 1967 under the bus station plan. More of the once fashionable terraced homes were swept away under the slum clearance programme started in 1955, affecting over 6,000 homes in a twelve-year period. Among those seeking a new dwelling was Preston Fire Chief Oliver Budd, who lived at No. 10, only a stone's throw away from the Tithebarn Street fire station.

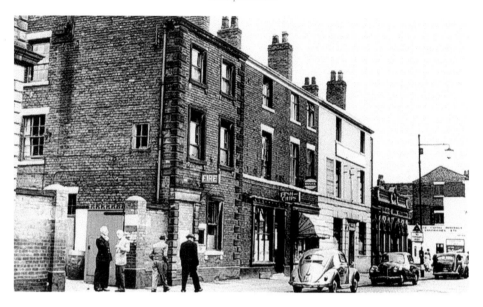

The part of Tithebarn Street pictured here *c.* 1960 was about to disappear as progress continued on the bus station development. Alongside the old fire station offices stood Green's fish and chip shop, Johnson's popular pie shop, the Market Hotel and the low building containing the Preston Weights and Measures offices.

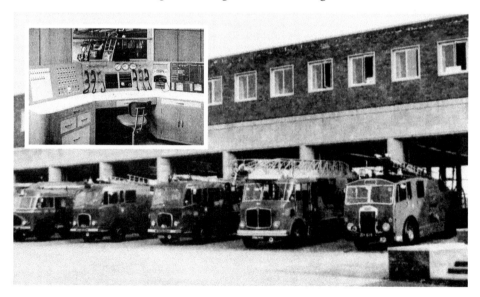

Preston Borough Fire Brigade moved to their new Blackpool Road premises on an old clay quarry site in April 1962 under the guidance of Fire Chief Oliver Budd. The new HQ was built at a cost of £154,000 and incorporated a control room that was connected directly to important buildings such as the Royal Infirmary and the Public Hall. It contained a training tower, parade yard, smoke chamber, conference rooms, dormitories and a canteen, making the firefighters' lives better. *Inset:* The control room with a view of the fire engines.

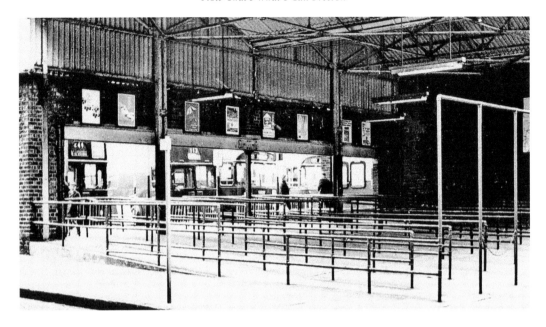

The Ribble bus station, pictured here in 1967 in a rundown state with its leaky corrugated-iron roof, would also soon be turned to rubble. It had been built in 1928 and the site was earmarked for the new Guild Hall development. Ribble Motors, who had taken over the Scout Motor Co. in 1961, became part of the National Bus Company in 1969 and eventually became part of the Stagecoach group.

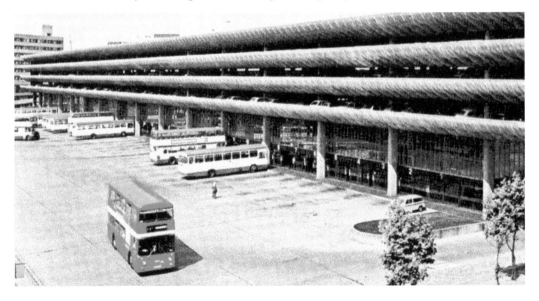

This image of the west side of Preston central bus station, opened in November 1969, shows the busy scene a few years later. John Laing Construction Ltd had fenced off the 6-acre site in March 1968 and earned praise for the speedy construction of the £1 million development. Even before construction was started the structure was given an award for its Brutalist architectural design by the *Architectural Design* magazine.

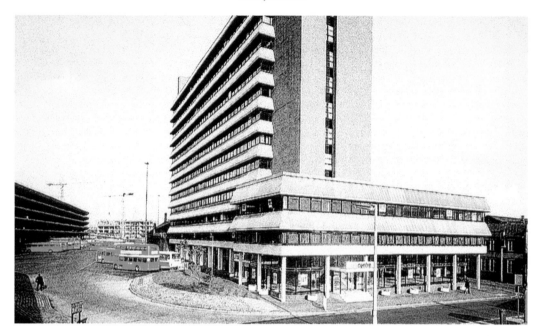

When completed in 1971 the Unicentre office block became the tallest office block in town, standing 150 feet tall. The structure with its concrete columns based on a Swedish building system transformed the Lords Walk scene. To the left on the east side of bus station concourse a row of Ribble buses awaiting departure can be seen. In the distance construction is underway on the Preston Crest Hotel.

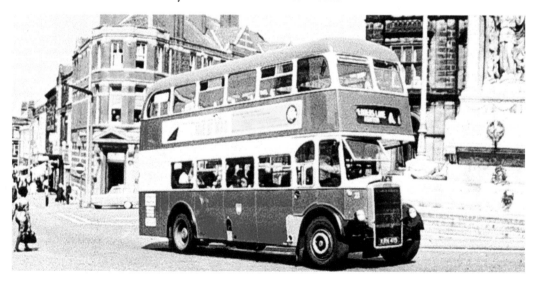

By 1969 the new bus livery of blue and cream was appearing as the maroon was phased out. Once more a bus returns from Pedders Lane in Ashton, although this time its destination is the new Tithebarn Street bus station. Double-deckers were still the mainstay of the Preston Corporation fleet, although single-deckers and pay-as-you-enter buses were in the offing after successful trials in 1966.

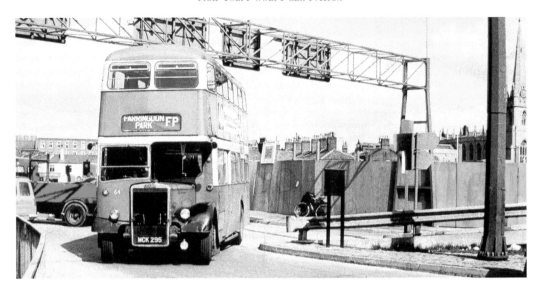

A Preston Corporation bus makes its way into the new bus station as work continues behind the hoardings on the building of the Crest Hotel. To the extreme right the spire of St Ignatius' Church on Meadow Street can be seen. The Farringdon Park route that this bus was taking was one of the busiest services with numerous halts along New Hall Lane.

A familiar sight in 1976 with a Fishwick Bus stopping on the Fishergate railway bridge. Passengers have the opportunity to glance in the window of T. Ball, the popular discount footwear store. Tommy Ball's son Terry operated from this site until the 1990s, selling shoes tied together by string. Prior to the opening of the central bus station, Fishwick terminated their services on Fox Street. The company ceased trading in October 2015, ending their familiar bus journeys to Penwortham, Leyland, Chorley, Coppull and Lostock Hall.

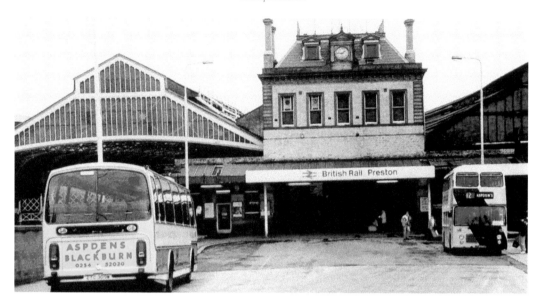

In its heyday Preston railway station had thirteen platforms, with trains for Blackpool departing from platform 1, to London Euston from platform 6, to Accrington and beyond from platform 10 and all stations to Southport from platform 13. At the dawn of the 1960s the railway station was still a great attraction for trainspotters wallowing in the glory of steam, although that was about to change.

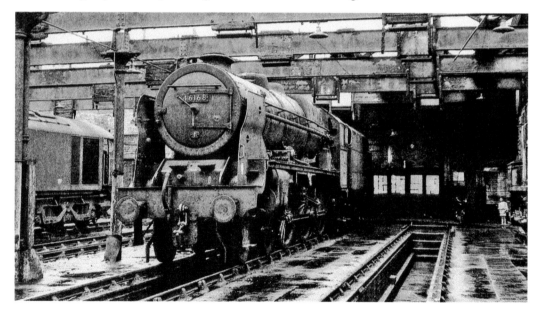

The burnt-out remains of the Preston Locomotive shed (No. 24K) on Croft Street pictured in August 1964. A huge blaze in June 1960 had destroyed the roof and twelve locomotives were severely damaged. Workers and locomotives were moved to the Lostock Hall sheds. Royal Scot class locomotive Girl Guide No. 46168, pictured here, was built in 1930 at the Derby Works and withdrawn from service in May 1964.

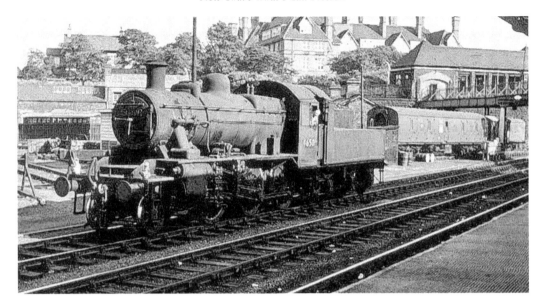

Ivatt LMS class engine No. 46501, built in 1952 at Darlington and withdrawn in 1967, approaches platform 7 in 1963 after travelling beneath the once covered walkway that was used to reach the Park Hotel shown in the background. The hotel, jointly built by the London & North Western and the Lancashire & Yorkshire railway companies, was opened in 1882 and was used by generations of railway travellers before being sold in 1950 to Lancashire County Council, who built a tower block of offices beside it.

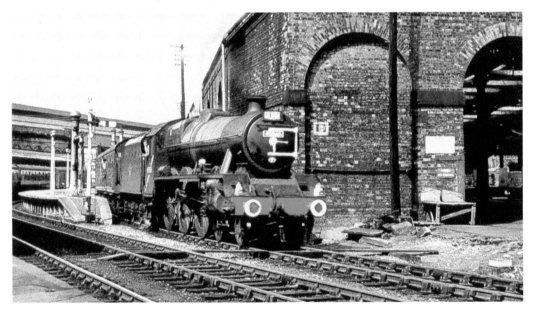

Steam locomotive *Victoria* No. 45565, of the LMS Stanier Jubilee class, departs with a special excursion train in 1965 from the East Lancashire side of Preston railway station, where a Butler Street entrance existed. The engine, built in 1934, was consigned to the scrapheap in January 1967.

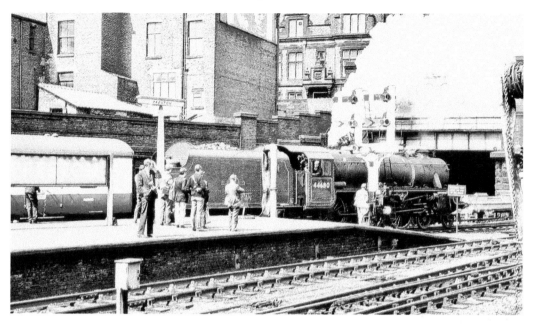

A popular Stanier-design steam engine No. 44680, known as a *Black 5* and built in 1950 at Horwich, prepares to depart from platform 1, destination Blackpool, in August 1967 with a tender packed with coal. Eager trainspotters look on as it builds up a head of steam. This engine was withdrawn from regular service a month later.

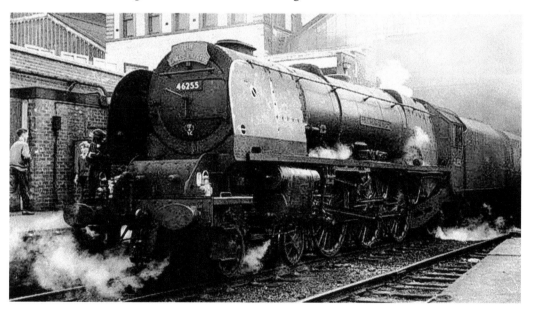

The 'Lakes Express' prepares to depart from Preston in 1963 with the 'Coronation' class engine No. 46255 – *City of Hereford* on duty. This engine, built in 1946 and based at Carlisle, was scrapped in December 1964. Often comprised of thirteen carriages when it passed through Preston, the 'Lakes Express' hauled different portions of the train that would end up at Keswick, Windermere, Whitehaven or Barrow.

Diesel locomotive D7618, allocated to Preston in 1968, can be seen hauling trucks through the station as it heads south. What is significant in this photograph is the connecting bridge fitted with a chain conveyor from the new sorting office on West Cliff to the railway station enabling letters and parcels to be transported between the two.

The West Cliff postal sorting office pictured in 1965. The three-storey structure was built in 1961, the intention being to replace the congested sorting office on platform 6 along with the Fleet Street delivery office. It was officially opened in October 1963 by postman Cyril Evan Molyneux, the Mayor of Preston. This building no longer exists and apartments occupy the site. The Royal Mail HQ nowadays is on Pittman Way, Fulwood.

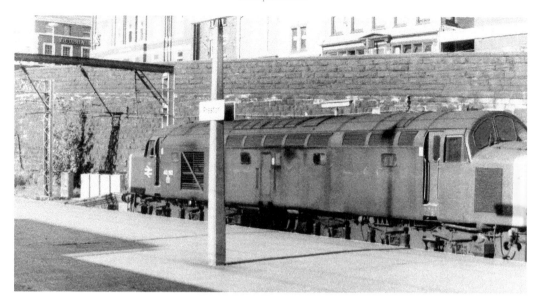

Diesel locomotive Class 40 No. 40192 stands on platform 6 next to Butler Street in 1981. On the skyline above the Victoria & Station Hotel on Fishergate can be seen, along with the Queen's Hotel, which was closed in 1982 prior to the Butler Street redevelopment taking place for the Fishergate centre, and the popular Railway Hotel, which survived the upheaval to remain on Butler Street.

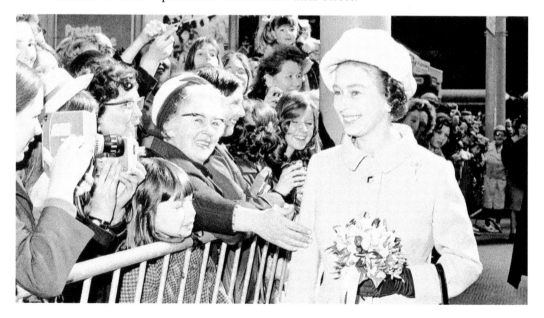

In May 1974 HM Elizabeth II visited Preston accompanied by the Duke of Edinburgh. Her Majesty was met at the railway station by enthusiastic crowds who were waiting behind the barriers to greet her with smiling faces and flags waving. While at the station the Queen unveiled a plaque to mark the final stage of electrifying the railway from London to Glasgow.

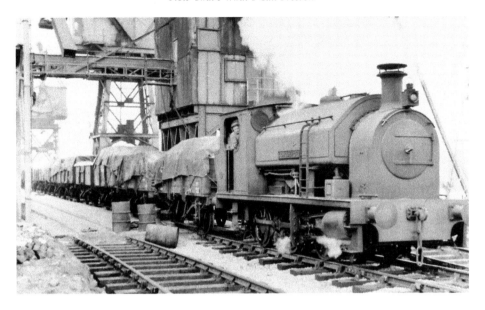

The Ribble Branch Railway from Preston station to the Preston Quay opened in 1846 to serve the area that eventually became Preston Dock. The dock railway was essential for transporting cargo, and here in 1965, 0-6-0ST Conqueror, a standard Bagnall 16-inch saddle tank, one of the seven Bagnalls used on the Ribble Railway, can be seen hauling a train of railway trucks. It was scrapped in 1968 when steam operations ceased on the docks railway.

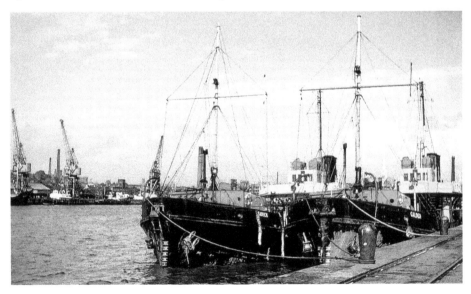

The scene on Preston Docks *c.* 1960 with dredgers *Calder* and *Savick* taking a break from their dredging duties. These two suction hopper dredgers had been in service since 1949 and were sold by 1976, fetching £16,000 from their foreign buyers. Dredging operations were always a necessity to maintain the depth of the channel and costs spiralled by the mid-1970s with £400,000 spent in a single year.

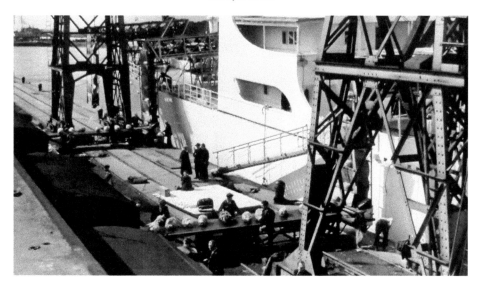

The unloading of Geest bananas was a common sight, as shown here in 1962. Two familiar Geest banana boats regularly berthed in the docks. Both MV *Geestland* and MV *Geeststar* made continual trips to and from the Windward Islands to Preston and Barry. On a typical trip over 900 tons of bananas would be unloaded onto rail transport.

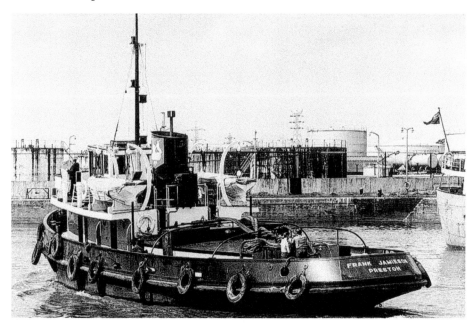

This image shows the twin-screw motor tug *Frank Jamieson*, which is named in honour of the former alderman and mayor of Preston. It was built in Leith, Scotland, for Preston Corporation in 1956 and was a familiar sight for the next twenty-five years. It costs over £72,000 to build and was sold in 1981 for £25,000. Alderman Jamieson attended his last council meeting in May 1964 and was later made an honorary Freeman of Preston.

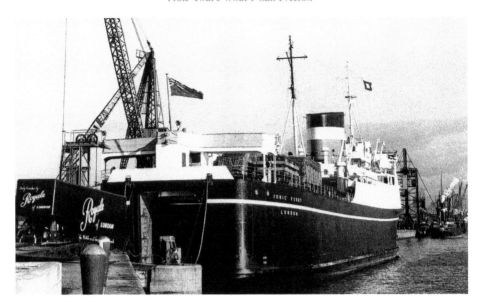

The Ionic Ferry can be seen here unloading in Preston Dock. From 1957 a ferry service between Preston and Larne was introduced with vehicles, containers and passengers arriving and departing on the high tides. The initial popularity of using the Bardic Ferry led to the introduction of her sister ship the Ionic Ferry as demand increased. These vessels and other transport ferry boats were withdrawn in the early 1970s contributing to the docks' decline.

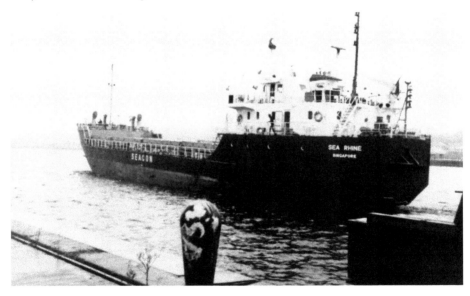

Merchant vessel *Sea Rhine* was credited with being the last commercial visiting ship to leave Preston Docks after offloading grain in mid-October 1981. The docks opened in 1892, as the latest venture for the Port of Preston, and officially closed on the last day of October 1981. Despite some profitable times in the 1960s, a gradual decline in transport ferry services and container traffic led to its inevitable closure.

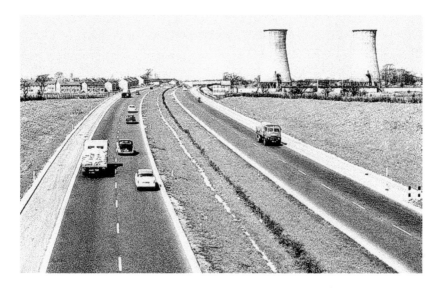

The Preston Bypass J29 to J32 officially opened in December 1958 to herald the dawn of motorway construction. This image shows a further stretch of the M6 motorway leading to Lancaster between J32 and J33 with the two-lane carriageways seperated by the grass verge felt to be sufficient at the time. This stretch of motorway included the Forton service area, which was opened in January 1965. The landmark Courtaulds cooling towers at Red Scar can be seen to the right. The towers were knocked down in 1984 with the motorway lanes closed off for a while.

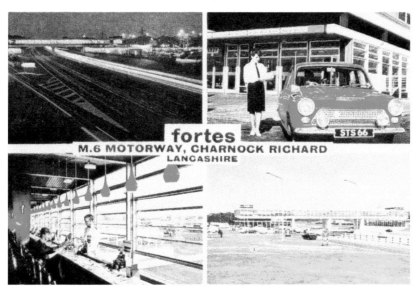

It was the dawn of the motorway service stations with the Fortes services at Charnock Richard the first to open in July 1963 as the stretch of the M6 from Preston to Warrington J20 to J29 was opened. There was parking spaces for 600 vehicles and no shortage of petrol pumps, although the high price of petrol was criticised. Minor vehicle repairs could also be carried out in the on-site garage workshops.

A welcome break for a lady from the cafeteria staff, who sits in the impressive bridge restaurant that could accommodate 300 customers at one sitting. Even in those days Heinz salad cream and HP sauce were as popular as ever. A couple of transport cafés and two snack bars along with a variety of shops made it a popular stopping-off point, although the food wasn't cheap.

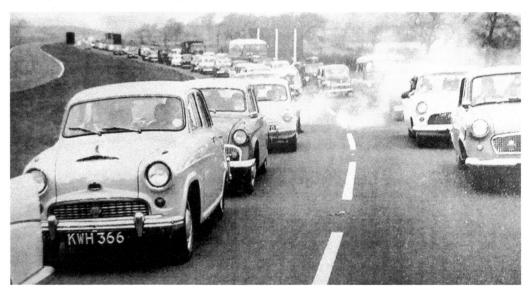

In January 1965 the stretch of M6 motorway from Broughton to Hampson Green (13.5 miles) was officially opened by Tom Fraser, the Minister of Transport. Unfortunately, the days of idyllic motorway travel were still a long way off. This scene on a bank holiday led to mounting frustration as cars lined up bumper to bumper and overheating engines caused despair.

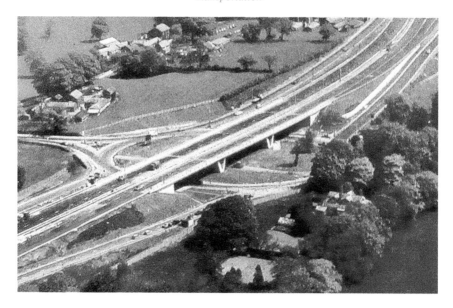

The M55 motorway, some 12 miles long, was officially opened in early July 1975 linking Preston with the seaside resort of Blackpool. This aerial view of the Broughton interchange section of the motorway reflects how complex motorway construction was becoming, with flyovers and slip roads aplenty.

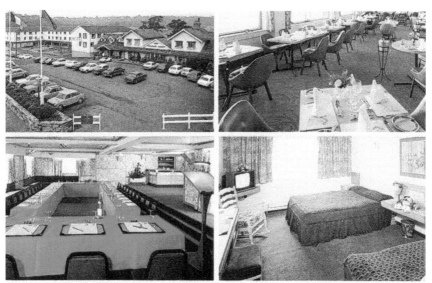

THE TICKLED TROUT HOTEL, Nr. PRESTON

With the coming of the motorways, hotels on the outskirts of town became increasingly popular. The Tickled Trout was one to benefit. Pictured in 1972, it was a welcome stop for Preston Guild visitors. Down the years it has developed as a significant motorway service area besides what was simply the Preston New Road to Blackburn, with the old toll-paying 'Half Penny Bridge' having developed almost beyond recognition. Collect a toll these days and you would make a fortune.

GLORIOUS GUILD

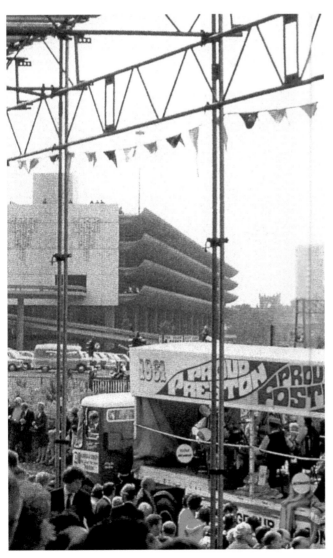

In 1972 it was once again the time for Preston Guild, another twenty years having passed. Unfortunately, the newly built Guild Hall was not quite ready in time for the ceremonies and celebrations. Many of the town's landmark buildings had been given a clean-up to rid them of a century of grit and grime and were floodlit for the occasion. Many a street was bedecked with bunting, banners and streamers and shop premises on the processional routes had displays on show to mark the occasion. Impressive processions took place for all to see; the Church of England procession alone had 8,000 participants. Fortunately the Guild Week was blessed with glorious sunshine for the numerous processions and outdoor pursuits. Sadly, Guild Mayor, Alderman Frederick Gray, who had, along with his sister, received lavish praise for their Guild contribution, was to die before the end in his year of office. Here we see a procession making its way past the new central bus station.

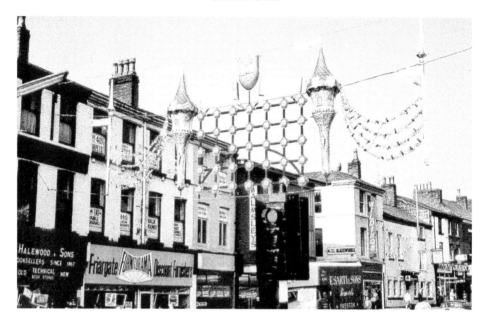

In true Guild tradition all the highways where the processions took place were gaily decorated, many displaying the lamb of Preston, as this view along Friargate shows. To the left Halewood & Sons can be seen, who had a Guild-flavoured window display, reflecting that it would be the sixth Guild since they began in business. Further along the highway the Dog & Partridge, a veteran of at least ten Preston Guilds, had brought out the bunting once more.

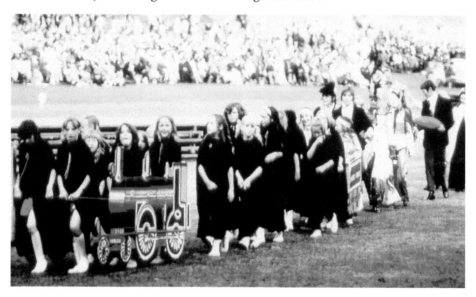

A pageant of Preston was performed by the schoolchildren of the town whose displays reflected the past, present and future. Over 3,000 youngsters took part and over 10,000 spectators filled the grandstands on Avenham Park. This group of children were happy to parade with a tablaeux of a steam locomotive from the past.

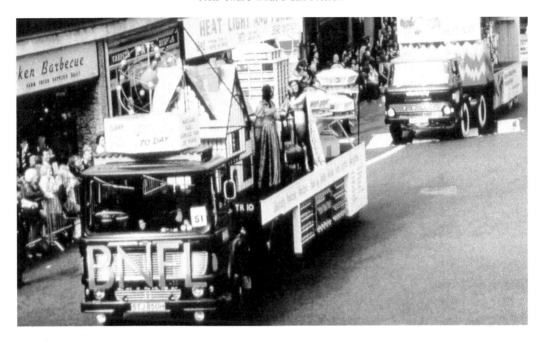

By the time of the 1972 Guild the former UK Atomic Energy plant at Salwick had become British Nuclear Fuels Ltd and they played their part in the Trades Procession, which drew large crowds on to the town centre streets as they celebrated twenty-five years of fuel supplies. 'Nuclear energy, the fuel of the future' was their message as they passed along Friargate.

The opportunity to bring all faiths together with the traditional church processions taking place, and their communities supporting each other, was a feature of this Guild. This group of walkers made their way along Church Street with clergy among them. The crowded footpaths reflect the enthusiasm of Preston folk for Guild processions.

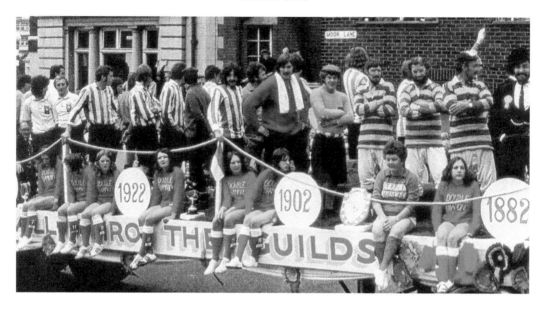

The footballers of the Preston & District Football League, begun in 1905, dressed themselves as footballers in the fashion of Preston Guild's past. Their colourful float was greeted by cheers as they made their way along Moor Lane. The ladies wearing shirts sponsored by 'Double Diamond' are sat on the float taking a break, having paraded alongside it for most of the procession.

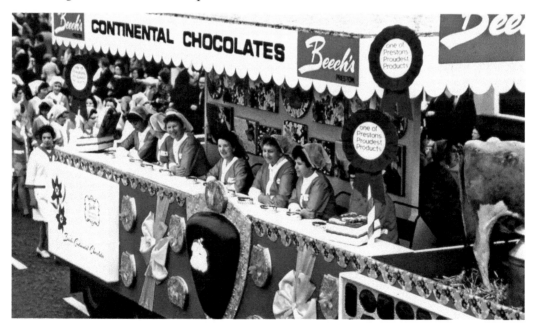

The enthusiasm for Preston Guild by the workers at Beech's chocolate factory on Fletcher Road, which opened in 1920, was never in doubt. The Guild of 1972 was no exception as they paraded on a float advertising their latest creation, their 'Continental Chocolates', a mouth-watering treat for customers at home or abroad.

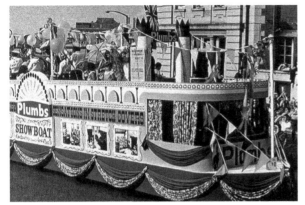

The local stretch covers manufacturers Plumbs, who were employing 1,000 workers in their business in 1972, and who were in the throes of moving to Brookhouse Mill yet still found time to decorate a float as a 'Showboat' displaying their fabrics. The float can be seen entering Moor Lane with the former Barclays Bank premises in the background.

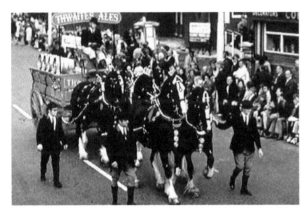

Popular as ever were the dray horses of Thwaites Ales. The Blackburn-based business founded by Daniel Thwaites in 1807 supplied a number of Preston's public houses down the centuries. No doubt a big cheer awaited them as they passed the Lamb & Packet and the Sun Inn on Friargate, both having cellars loaded with Thwaites beers.

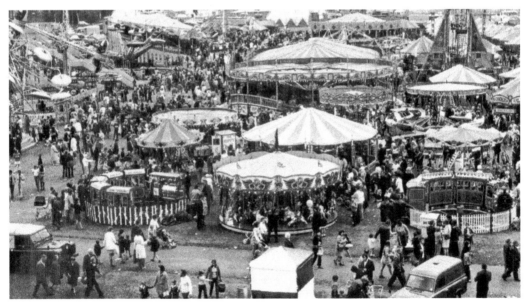

The Guild Fair on Moor Park was one of the most popular events. With a great tradition of Whitsuntide Fairs in Preston, it was no surprise that the great showmen of the fairground world would rally in support of the Guild traditions.

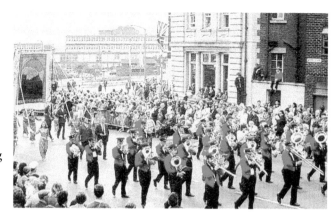

No Preston Guild would be complete without the traditional brass bands and they turned out in force. This group still had a spring in their step and music to play after marching their way through town.

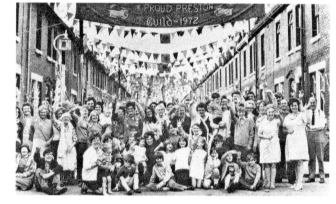

The residents of Mersey Street in Ashton won the coveted 'Best Decorated Street' award. After hearing of their success they gathered with many a smile and waved for the camera.

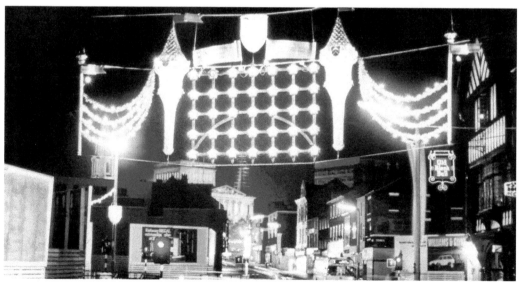

The Torchlight Procession is always a Guild highlight and this image shows the town lit up in preparation for the fun-filled parade. The new Ringway road splits Friargate into two and in the distance the tower of the Sessions House, the Harris Museum and Crystal House are prominent around the Market Place where eager crowds gathered.

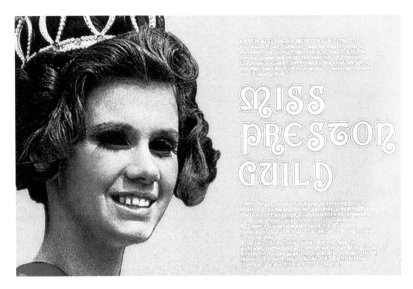

The clamour to be crowned Miss Preston Guild attracted a bevy of beauties and the winner was Karen Alexandra Mortenson-Fowler, who was described as pretty, bright and ambitious. Besides her duties as Miss Preston Guild she also danced in the Guild production of *Camelot*. Her reward for winning was a ten-day holiday for two in Miami with return flights on a BOAC747 and £200 spending money. In the years that followed Karen took part in the televised Miss England, Miss United Kingdom and the Miss Great Britain contests.

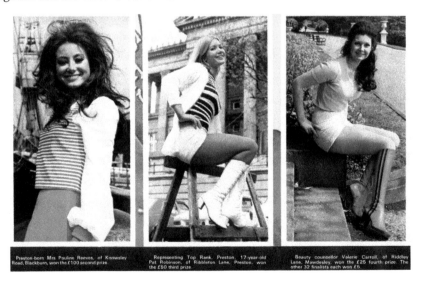

Preston-born Mrs Pauline Reeves, of Knowsley Road, Blackburn, won the £100 second prize.

Representing Top Rank, Preston, 17-year-old Pat Robinson, of Ribbleton Lane, Preston, won the £50 third prize.

Beauty counsellor Valerie Carroll, of Riddley Lane, Mawdesley, won the £25 fourth prize. The other 32 finalists each won £5.

Equally stunning were the runners up: Preston-born Pauline Reeves won £100 for second place; third-placed Pat Robinson, representing Top Rank, was given £50; and fourth-placed Valerie Carroll was awarded £25. The other thirty-two finalists, from a competition contested by over 500 girls, were each awarded £5 for participating. Pauline Green won a string of titles including Miss Schubette, Miss Hibernia, Miss Lancastria, Miss Road Safety and British Pet Queen.

LEISURE & PLEASURE

Entertainment comes in many variations. Some may adore a shopping trip, or a meander through the market. Your ultimate indulgence might be a night in a posh hotel, or a cosy evening on the sofa watching television, while others may yearn for a dance or to attend a pantomime.

An indoor market, a covered market, pot fairs, traffic-free shopping centres and a hot potato seller all making a stroll through the town centre more pleasurable for some. Television had brought the death knell for many a picture house, theatre or dance hall. Yet the fight back was on, at least for a while, and for the cinema it was as simple as ABC. Some reckoned that video had killed the radio stars, but Preston was to have its own radio stars as Red Rose Radio was born. Life had its perks as Preston North End footballer Willie Irvine found out as the winner of the 'Candy Girl' contest sat on his lap.

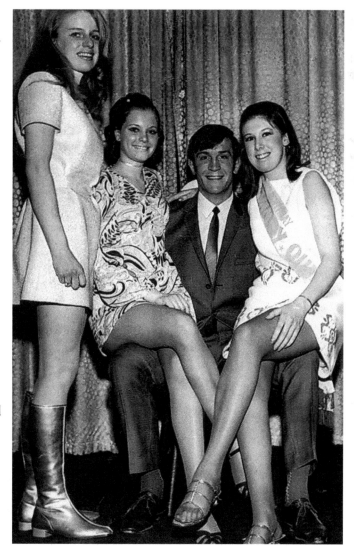

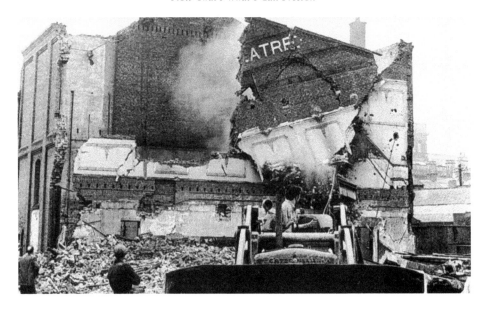

In July 1964 the bulldozers were busy on Tithebarn Street as the final curtain fell for the Prince's Theatre on the corner of Crooked Lane. The famous building had echoed the voices of many famous artists from its opening in 1882 when it was known as the 'Gaiety Place of Varieties'. After forty years of live theatre it was converted to a cinema enjoying much success. It closed in 1959 and on the agenda for the site were the Buckingham Bingo Hall and St John's Shopping Centre.

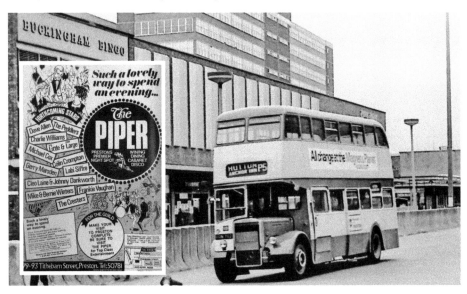

In 1970 a Preston Corporation bus heads off to Hutton and on Tithebarn Street the scene has changed. It's eyes down for a game of bingo at the purpose-built Buckingham Bingo Hall and the St John's Shopping Centre, which opened in 1967, offers an alternative shopping venue. To the right of the photograph beneath the car park the Piper nightclub was calling the tune. *Inset:* The Piper offering fun in 1972.

ODEON PRESTON OPENS

Preston's new Odeon, in the luxurious Top Rank Entertainment Centre, comprising cinema, ballroom and restaurant in the rebuilt Gaumont, was opened on Monday by the Mayor of Preston, Counc. James Atkinson, who was welcomed by Kenneth Winckles, managing director of The Rank Organisation. Leslie Phillips, who arrived in "The Fast Lady", and Stanley Baxter visited Preston for the opening. Kenneth Winckles, speaking at the opening said: "One gets angry when one hears people saying the cinema is dying, dead, finished. This is utter nonsense. The cinema industry has taken a tremendous hammering, but statistics obscure the true story. The cinema is reshaping itself to the needs of the 1960's," he said, and continued "Preston Odeon is a fine example and proof of the faith in the future of the film industry. The demand for entertainment is as great as ever. Fewer films are being made, but more good ones. Rank has backed its faith with hard cash for modernisation and rebuilding of cinemas and this faith is already fully justified."

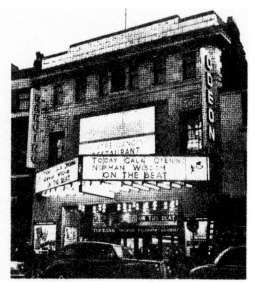

In January 1963 a luxurious Top Rank Entertainment Centre was opened in Preston on the site of the former Gaumont cinema. Comprising a cinema, ballroom and restaurant, it was a brave new venture. For the next decade it would be Preston's premier place of entertainment. At the Gala opening of the Odeon cinema stars Leslie Phillips and Stanley Baxter put in an appearance. The film that night was *On the Beat* starring Norman Wisdom.

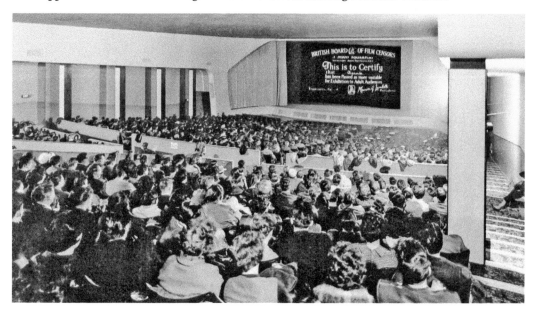

To create the new-look cinema the floor of the old Gaumont cinema circle was extended and the old domed ceiling removed. The seating capacity of the cinema was over 1,200. Audiences flocked to the new cinema and films such as *Goldfinger*, the Bond movie starring Honor Blackman, had the full house notices posted in January 1965. Glorious technicolour and a stereo sound system added to the luxury.

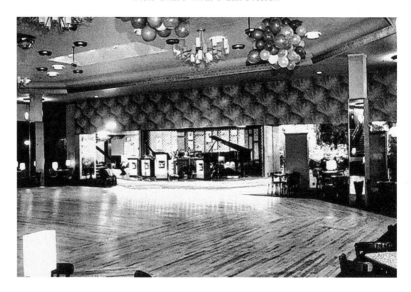

The Top Rank ballroom would host a diverse collection of events with Vin Sumner, the regional manager of the Top Rank, attracting a host of star attractions. Previously he had been a dance band promoter for the Queen's Hall and the Public Hall. For the first four years dancers took to the floor to the music of Johnny Wollaston and his resident band and later Eric Baxter took on the role. A rotating stage was a notable feature of the plush ballroom.

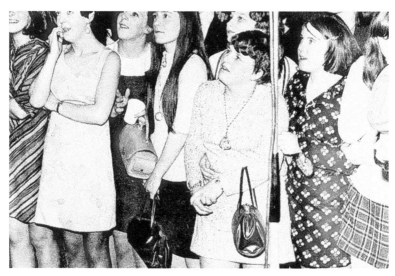

This image shows stage-struck teenagers at the trendy Top Rank ballroom, where there was never a shortage of groups and bands to attract the youth of the town in the 1960s. This group of girls gathered in front of the stage in a happy mood to watch and listen to the tuneful melodies. In 1968 when pop band Love Affair appeared things reached fever pitch as up to forty girls fainted in the crush to reach the stage. Numerous excitable occasions are still recalled with fondness when the likes of the Herd and Amen Corner appeared in concert.

In 1964 it was time for a 'Mother & Baby' contest at the Top Rank, sponsored by Cow & Gate baby foods. These mothers with their bouncing babies look like they are all worthy winners. However, the actual winner was Mrs Broadbent from Warrington pictured second from the right on the top row of this photograph.

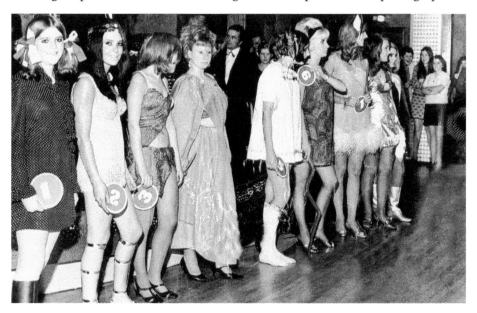

A Brooke Bond tea fashion contest was just one of the attractions during the Top Rank years. This line-up of glamorous competitors made it difficult for the judges, who often included resident DJ Jason Dee. There was no shortage of contests or fun events taking place and titles to be won, whether it be 'Miss Hot Pants', the 'Birthday Princess', 'Miss Candy Queen', ' Miss Teen Queen' or 'Cover Girl' for Vanity Fair.

The Guild Hall opened in early November 1972. A decade later entertainment officer Vin Sumner prepared a tenth birthday celebration as he reflected on the diversity of the venue. Sporting events headed by the UK Snooker Championship included boxing, table tennis and badminton. Among the month-long birthday events were the BBC's *Come Dancing* qualifiers, a sportsmen's dinner, appearances by the Nolan Sisters and the Royal Liverpool Philharmonic Orchestra. Of course his favourites, the Syd Lawrence Orchestra, would also be there. His greatest memory was the visit of Bing Crosby in 1977.

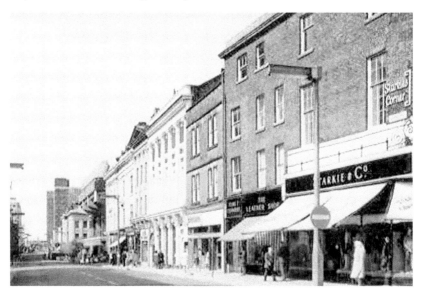

The new Guild Hall and towering office blocks can be seen in the distance in this changing view of Lancaster Road in 1973. Starkie & Co., men's outfitters, were still on the corner of Church Street, next to 'The Leather Shop' and Johnson's the dry cleaners in the row of buildings called 'Stanley Chambers'. Next to Johnson's is the Tea Bar, a place for 'King Size Sandwiches' and a mug of tea.

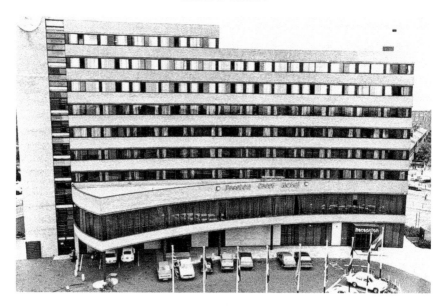

The Preston Crest Hotel, pictured from the bus station, was opened in August 1975 when the old Bull & Royal, also owned by the Bass Charrington Crest Hotel group, ceased to function as a hotel. The lavish new building had over 130 bedrooms and four private suites. Conference rooms, public and private restaurants and dance facilities all added to the attraction. A single room cost £7.50 per night and a double room was £9.50. In the 1990s it was known as the Forte Posthouse and is nowadays the Holiday Inn.

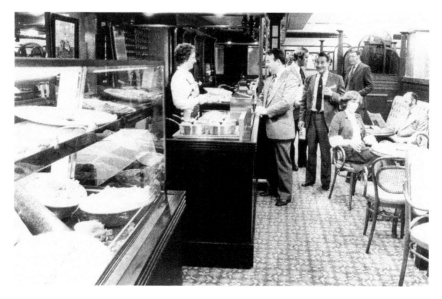

Guests relax in the new Bull & Royal bar within the Crest Hotel where friendly staff were on hand to serve hot bar snacks. At your service was the theme, whether you ate in the bar or dined in the plush Hamilton restaurant, or indeed required room service.

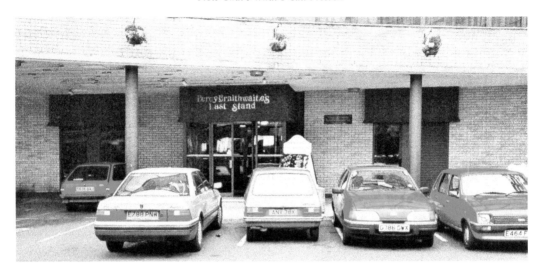

Percy Braithwaite's Last Stand was the public bar opened within the Crest Hotel. Pictured here in 1987 when Preston had close to 150 public houses, it was a popular venue until 1993, when it closed. It was a handy place for a last pint before catching the last bus departing from the central bus station in days when closing time was eleven o'clock at night.

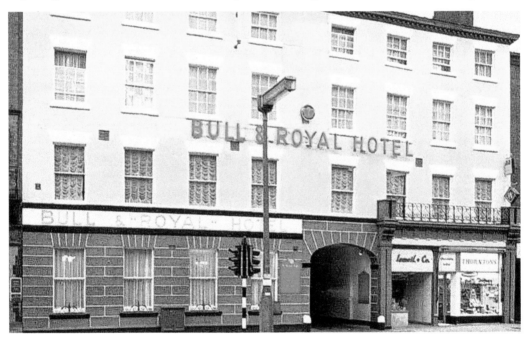

The future of the Bull & Royal Hotel on Church Street had been uncertain following the opening of the Crest Hotel, but after two years of wrangling it was announced in October 1977 that, following approval by government ministers, it could reopen as a public house serving food and drink. Other parts of the hotel, such as the historic Derby Room and stylish ballroom, were available for other business and leisure pursuits. Nowadays it carries the sign 'Old Bull' and incorporates 'Harrys Bar'.

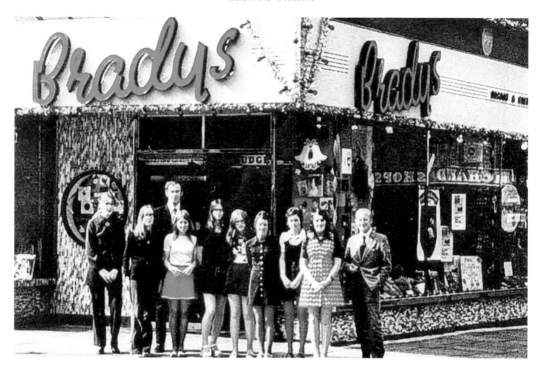

One of the most popular haunts for record collectors, in an age when vinyl records and cassette tapes were all the rage, was the Bradys record store on the corner of Crystal House. The staff are on parade in 1972 outside the store, which also had a basement packed with recordings from popstars and those of a bygone age.

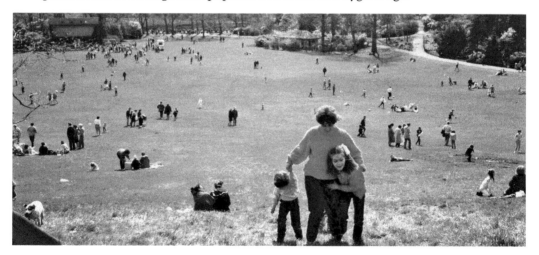

There can be few greater pleasures than playing on the grassy slopes on a summer's day, as seen in this picture down the valley of Avenham in 1988. Some have brought along a picnic, others are hoping for an ice cream and a group are gathered in the distance around the bandstand hoping the band will play on. Ever since the Avenham Park was officially opened in 1867 it has been a source of enjoyment and the Easter egg rolling tradition of Easter Monday lives on.

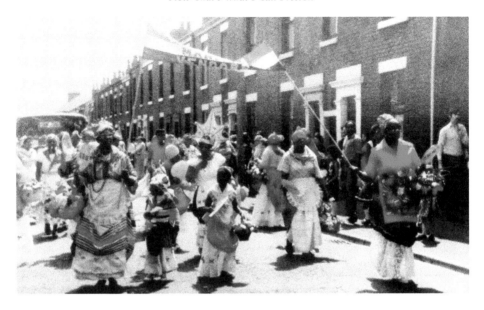

The Guild of 1972 had seen the Caribbean community of Preston show off their carnival skills. It was followed in 1975 by the first annual Caribbean Carnival processions, and this scene from 1978 shows the procession in full swing. It was a chance for those who had arrived in Preston from places such as Barbados, Trinidad, Jamaica and Montserrat to delight local folk. The streets of Deepdale came alive with calypso music and gaily decorated walkers.

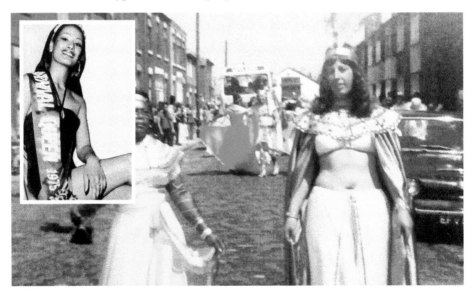

Another scene from 1978. Balloons, banners and steel band music brought the streets to life. Original members of the Jalgo's club, opened in 1963 in Rose Street, were a major force in bringing communities together and were among those on parade. *Inset:* The first Carnival Queen contest was held in the Caribbean Club in Kent Street in 1975 and was won by Diane Greenidge.

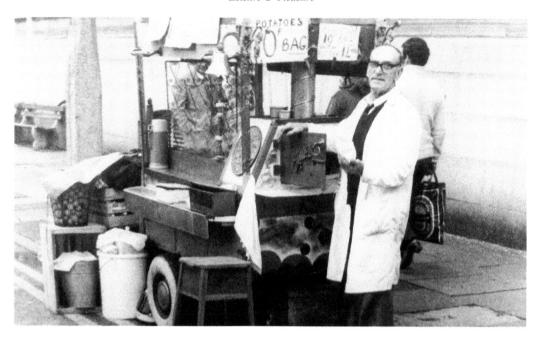

On a visit to town in the 1970s you could not fail to miss the hot potato man. He had moved with the times and 10*p* had replaced 2 shillings for a bag of spuds, with butter costing 4*p* more. The popular Teddy Taylor had set up his cart on Birley Street in view of the Market Square.

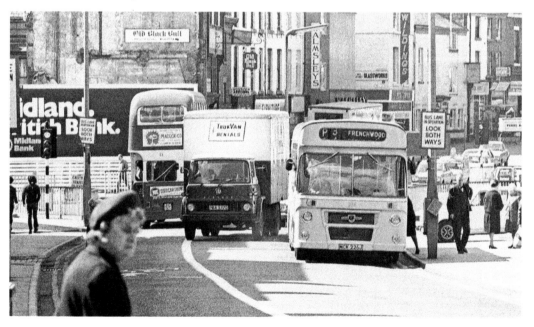

If out shopping you had to keep your wits about you, just like this lady in 1972 who had a bemused look on her face after the introduction of new bus lanes on Friargate – 'Look both Ways' being the message pinned on the lampposts.

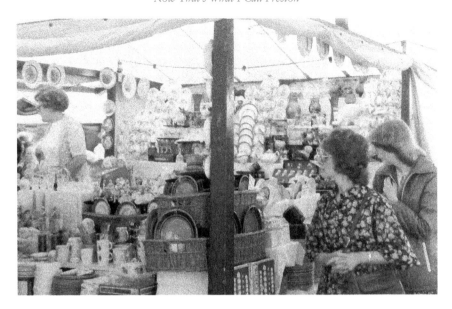

The Preston Pot Fair of August 1976 was held in the Market Place and was as popular as ever as folk gathered to replace their broken crockery. The plate jugglers and the wit and patter of the stallholders prove an unmissable attraction. According to the sellers the bargain of the century was yours at a knockdown price, be it a bone china tea set, a cherished teapot, a set of crystal glasses or a mug for your tea.

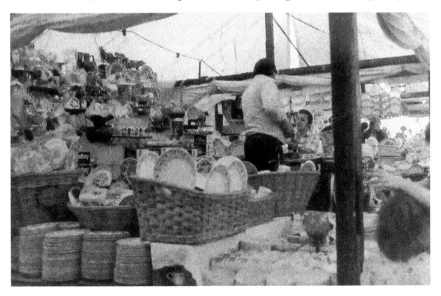

In August 1970 it was reckoned that a week's trading had brought sales figures of over £250,000. Alan Jenkins, a trader from Staffordshire, and his father before him, had spent forty years visiting Preston's annual crockery sale. He had with him 6 or 7 tons of pottery including matching dinner services for 30 shillings. He reckoned that a good pitcher with the right patter would turn over £60 in an hour. The Pot Fair continued until 2008, by which time its popularity had dwindled.

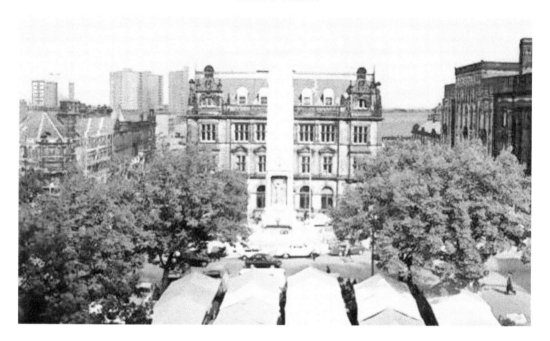

The Market Square full of stalls was a familiar sight throughout the decades. It was used not only for the Pot Fair but on numerous other occasions when traders desired to sell their wares, be it a craft sale, a day for bric-a-brac or fresh produce on a farmers' market day.

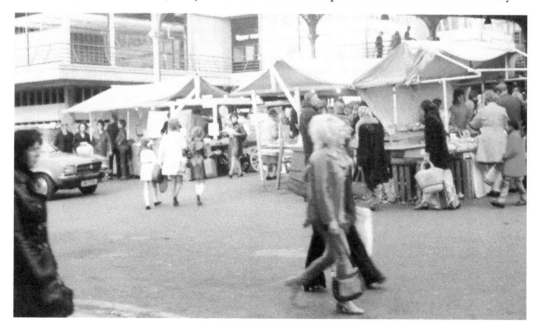

The Preston Covered Market was a busy place in late October 1972 just days before the new Market Hall building, which can be seen the background, opened. It was the last opportunity for the shoppers of Preston to wander through the familiar fruit and vegetable stalls on the outdoor Covered Market and to visit the fish stalls underneath the Fish Market canopy.

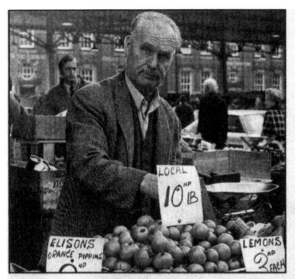

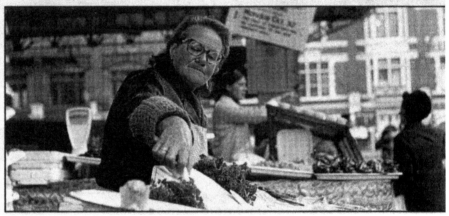

OUT WITH THE OLD: Traders on the very last outdoor food market to be held in Preston

Some of the old market traders display their fruit, vegetables and fish on their outdoor market stalls for the last time with many having mixed feelings about the imminent move indoors. Cheese seller James Butler feared his trade would be cut by half; Tom Dixon, a fruit and veg trader, felt the old atmosphere would be gone; flower seller Len Percival claimed he could not afford the switch; and veteran fish seller Edna Catterall described it as the end of an era. The new Market Hall was ready for business by November 1972 and it had cost £773,000 to build. The indoor Market Hall was certainly successful down the years with upstairs and downstairs traders catering for food, fashion and flights of fancy. Its existence was relatively short-lived, closing in 2018 as the new Market Hall beneath the Victorian canopy of the Covered Market opened.

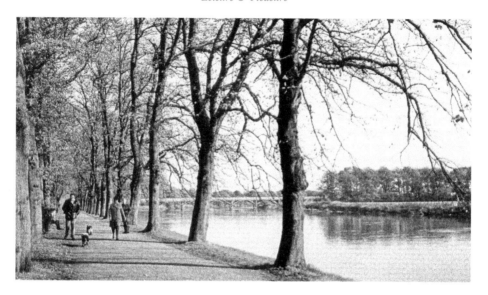

Preston is blessed with public parks and open space in abundance for those whose leisure time pleasures include a walk in the park or a stroll in the countryside. Avenham, Miller, Moor, Grange, Waverley, Ashton, and Haslam parks all have their own attractions. Avenham Park is a favourite of many and here a couple of dog walkers stroll along the tree-lined path besides the River Ribble, with the Old Tram Bridge in the distance.

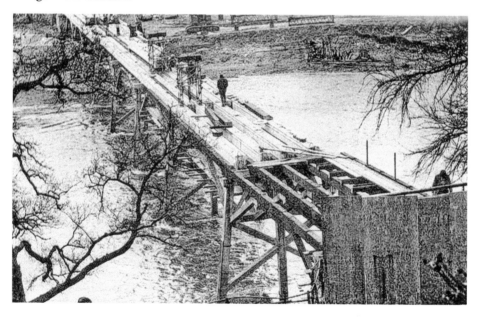

The Old Tram Bridge, which once carried coal wagons from the Lancaster Canal at Preston to a canal link at Walton Summit, was in need of serious repair, as seen here in 1966. The original wooden structure is in a dilapidated condition. Fortunately, repairs were underway and concrete supports and structures rescued it, enabling Preston folk to once more gain access to the countryside beyond.

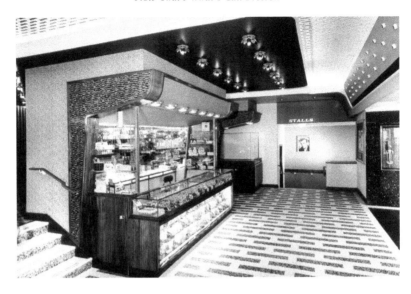

The plush new foyer at the ABC Cinema on Fishergate pictured shortly after its opening. Built on the site of the old Theatre Royal, which closed in 1955, the modern building had seating and stalls at circle level. On the opening night in mid-March 1959 film star Richard Todd put in an appearance and the first film shown was *The Reluctant Debutante* starring Rex Harrison.

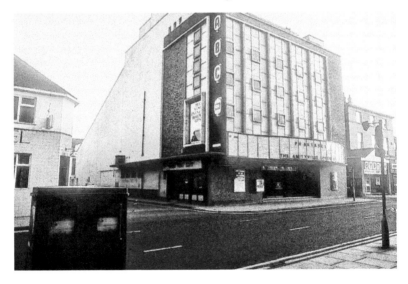

The ABC Cinema pictured in 1982. To the side on Theatre Street its public bar, the Painted Wagon, can be seen, which was added in 1973 – the name is inspired by the 1969 film *Paint Your Wagon* starring Lee Marvin. The bar was constructed in the rear stalls area beneath the circle. The cinema closed its doors in September 1982 with fourteen staff set to lose their jobs following a decline in attendances. The last film shown was a double-X certificate feature the *Amityville Horror* and *Phantasm*. To the right is an Oyston estate agency shop, a business established in 1960 with the innovative 'No Sale, No Pay' policy proving successful.

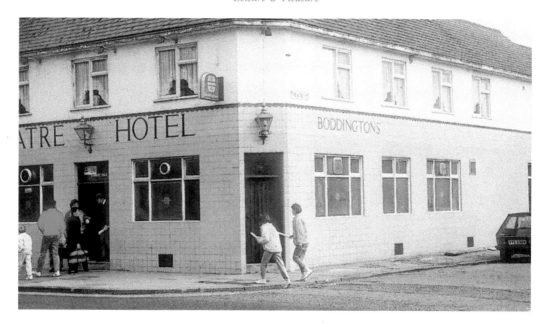

The Theatre Hotel, pictured here in 1982, can be traced back to 1805 when the old Theatre Royal stood on the ABC Cinema site. In 1960 the premises were completely blitzed to create the modern building, with the bar remaining open amidst the scaffolding, a practice that was discontinued after the horrific tragedy at the Greyhound Hotel months later.

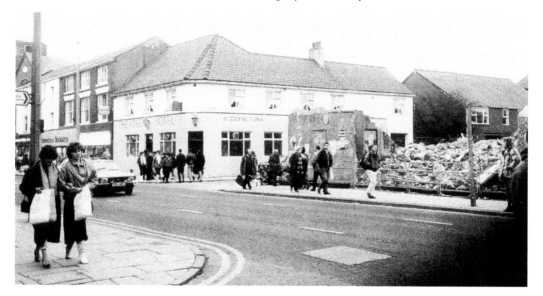

This image from 1987 shows the ABC Cinema being reduced to rubble. Beckhampton, owners of the ABC Cinema, had planned to use the shell of the building as the foundations for a luxury department store, but it was demolished in its entirety and shop premises were built there. The Theatre Hotel to the left was closed without warning in October 1987 when owners Boddingtons sold the site leaving the pub's regulars stunned. Further to the left among the row of shops was Sweetens Bookshop, a flourishing store in the 1980s.

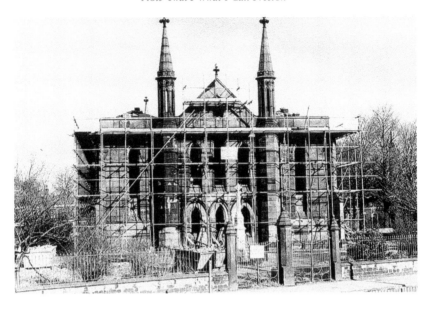

St Paul's Church pictured in 1981 as work gets underway to transform the building that was opened in 1826 and closed in 1973. The church graveyard was revamped, many of the tombstones were moved, the grounds were landscaped and the human remains left undisturbed. Over a seven-year period ending in 1849 there had been 3,579 burials with many of the graves holding twenty-five coffins. Burials ceased here in 1856, a year after the Preston Cemetery opened.

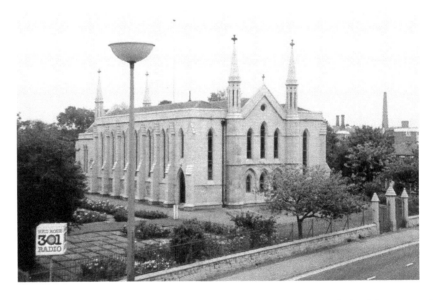

Red Rose Radio was launched in 1982 after restoration work had been carried out on the church. After eight years of neglect the building was lovingly restored. Tycoon Owen Oyston was the founding chairman of the commercial radio enterprise. Their slogan 'Music from the Sixties, Seventies and Eighties' soon attracted the listeners.

John Gillmore became a firm favourite on Red Rose Radio after spending a number of years as a volunteer with a local hospital radio station. He hosted a variety of programmes from the overnight graveyard shift to the five-hour-long football programmes covering the Lancashire teams. He left in 1998 to join The Bay radio station covering the Morecambe and Lancaster area. He joined Radio Lancashire in 2005 and his much-loved afternoon shows have made 'Gilly' as popular as ever.

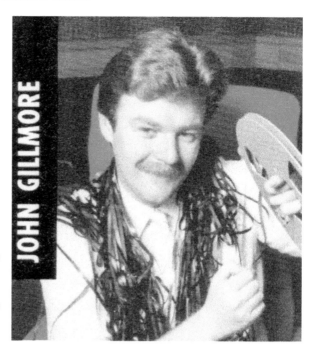

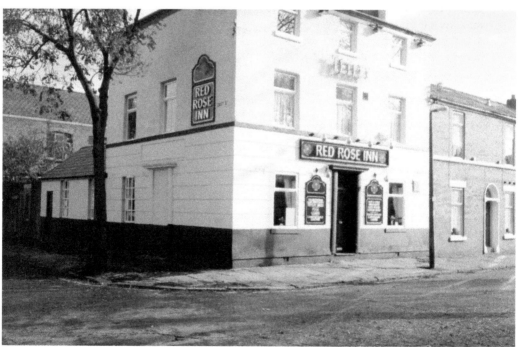

The Red Rose Inn on St Paul's Square, pictured here in 1989 shortly after it opened. The former Edinburgh Castle enjoyed a new lease of life after lying derelict for a while. With origins dating back to 1838, the Edinburgh Castle had been a much-loved local. The Red Rose Inn flourished for a while, having a place in the media spotlight. It closed in 2006 and is now private housing accommodation.

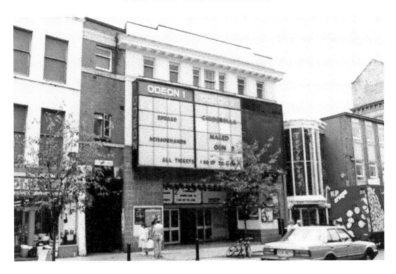

The Odeon cinema on Church Street had by early 1970 become a two-screen cinema, with Odeon 2 created in the former café space with seating for 112. By the mid-1960s cinemas had already felt the impact of the television age, although you could still visit the Ritz, Palladium, Empire and Odeon in the town centre. The Odeon was to emerge as the great survivor until September 1992 when the opening of the UCI cinema on the old Preston Docks site in 1990 (later named Odeon) finally led to its closure.

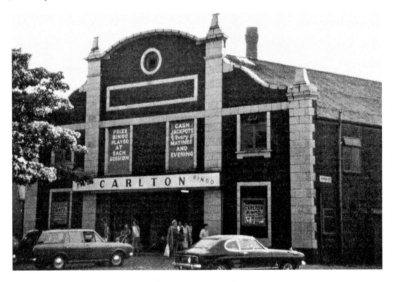

The Carlton cinema on Blackpool Road opened in August 1932 amid claims it was the only cinema in town built for talkies. The 650-seat auditorium was eventually equipped for Cinemascope. Although as an independent cinema it was low in the pecking order for new releases, it often had full house notices. The most popular film shown there was *Seven Brides for Seven Brothers*, which was booked on ten separate occasions. After closing in 1961 it was converted into a bingo hall, and the old balcony was turned into offices.

SPORTING LIFE

The following pages take a brief look at an era when leisure time gradually became more available and many turned their attention to sporting activities. In decades past Preston folk had been fascinated with the exploits of Preston North End, or Preston Grasshoppers, or Preston Cricket Club, or the dogs at Preston Greyhound Track or, indeed, the boxers who had developed their pugilistic skills.

Yet the next generation would look to participate in sporting activity, although the days of open-air swimming baths on Haslam, Moor and Waverley or the plunges at Saul Street, which had served the locals well, were numbered. It was the leisure centres at Fulwood and West View that would enable pursuits such as squash, badminton, table tennis and basketball, as well as swimming and saunas to attract the crowds. Running for life also became the habit for many, whether on road, track or trail, while the bicycle, which had often be used merely to get to work, was growing in popularity and pedal power and cycling gear became fashionable. Footballers wanted more than a kick in the grass and the organised local leagues and cups created great interest. It was the end of an era when Tom Finney shook hands with a spectator as he made his way out of the dressing rooms for his final appearance at Deepdale versus Luton Town at the end of April 1960, a match PNE won 2-0 with Alex Alston and Jim Smith scoring.

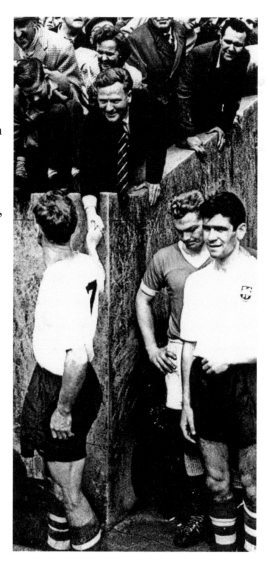

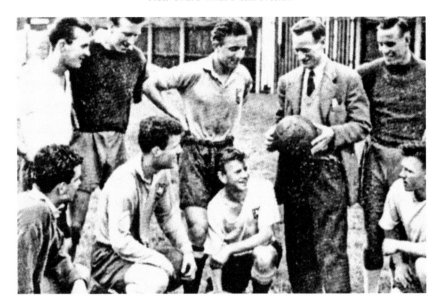

On the sporting front, although Tom Finney was close to retirement he was on hand to offer advice to the PNE youth. Good advice it seems, because the team reached the FA Youth Cup final of 1960 where they lost a two-legged contest 5-2 against Chelsea after drawing the first leg 1-1 at Deepdale. From that team emerged starlets John Barton, George Ross, Dave Wilson, Peter Thompson and Alan Spavin, all of whom became PNE regulars.

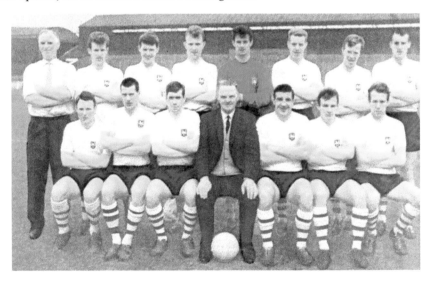

This is the Preston North End team of 1963/64 who almost achieved an unlikely double. With former youth stars Ross, Wilson and Spavin in their ranks they challenged Leeds and Sunderland for the old Second Division title only faltering on the final run in, perhaps distracted by their bid for the FA Cup. After defeating Swansea in the semi-final they put on a great show at Wembley where West Ham beat them 3-2 with a late winner.

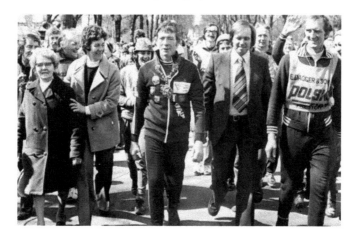

Tom Benson, seen here walking along Moor Park Avenue with his band of supporters, became a familiar sight. Walking was a great passion for the Preston postal worker from Ribbleton Avenue, who in his mid-1940s took on the world. In 1977 he trudged non-stop for 118 hours around Moor Park covering 314 miles to become the world champion long-distance walker. More records followed in the years ahead as he raised huge sums for charity and his ultimate effort was a 414.8-mile trek around Moor Park, his sixth world title. In tribute to him the new Ingol Distributor Road, opened in December 1985, was named Tom Benson Way. He died in June 2013, aged eighty.

The Saul Street swimming baths site pictured here was sold in October 1989 for £800,000 to the Home Office with plans to build the new Preston Crown Court there. The Saul Street baths, built in 1936, had served Preston well, but the age of leisure centres was upon us with swimming pools incorporated in the new leisure centres at Fulwood, on Black Bull Lane, which opened in June 1976, and West View, in Ribbleton, which opened in May 1986 on the site of a disused iron foundry, with a diverse range of sports on offer. West View was so popular in the first year that it attracted over 250,000 visitors, and in April 1987 Princess Diana paid a royal visit.

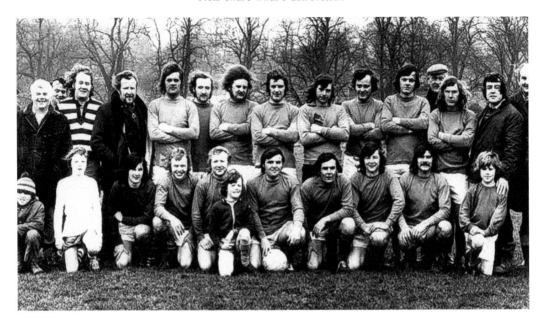

Sunday morning football came to the fore in 1967 when twenty-four clubs became founder members of the *Lancashire Evening Post* Sunday League, with Belfast Tea, Continental Casuals and the Higher Bartle Prize Band among them. Ingol Rangers, pictured here and based at the John O'Gaunt public house in Ingol, were formed in 1974 and became one of the league's most successful clubs under the guidance of manager Jock Wilson.

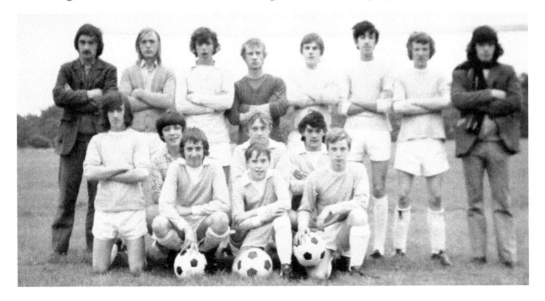

The St Hilda's youth football team, pictured here in 1973 before a fixture on Grange Park, were a member of the Preston & District Catholic Football League. Despite failing to win a league match in their first season (1971/72) they improved considerably in the years ahead and by the 1975/76 season they had progressed to the Senior Division as Windsor FC and gained some notable victories along the way.

Inspired by the first London Marathon in 1981, the people of Preston started to don their running shoes and on the streets and in parks runners were a familiar sight. The *Preston Citizen* newspaper, with keen runners in their midst, organised a race from Moor Park in Deepdale to Witton Park in Blackburn in late September 1981. Despite the torrential rain and stamina-sapping hills it was a great success.

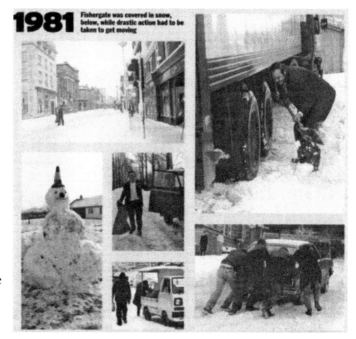

1981 Fishergate was covered in snow, below, while drastic action had to be taken to get moving

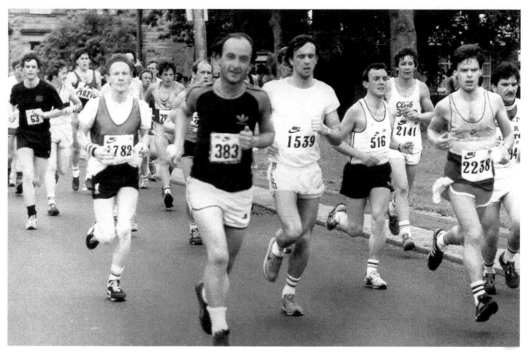

Many more races and fun runs were added to the calender locally and new running clubs such as Red Rose Road Runners were formed. Pictured here, a group of runners making their way through Grimsargh in the annual Great North-Western half-marathon in 1984. Author Keith Johnson, wearing No. 383, is among the following pack of an event that started and finished on Moor Park.

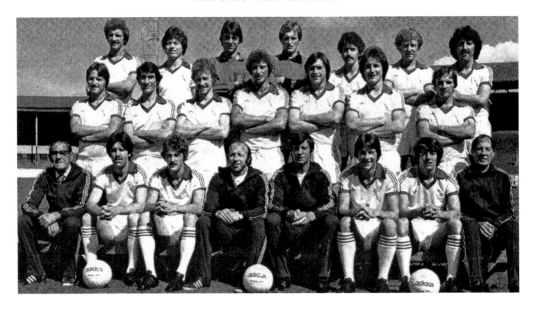

This Preston North End team of 1978/79, managed by Nobby Stiles, had restored some pride after a dismal spell. Stiles led them to promotion from the old Third Division as Alex Bruce netted thirty goals. The following two seasons they finished seventh and tenth in the higher division only to slip out of the division again in the 1980/81 season despite a last-day win at Derby County by 2-1 as Alex Bruce netted twice. That summer Stiles was axed as manager and former PNE favourite Tommy Docherty took up the role but was also sacked just seventeen league games into his reign.

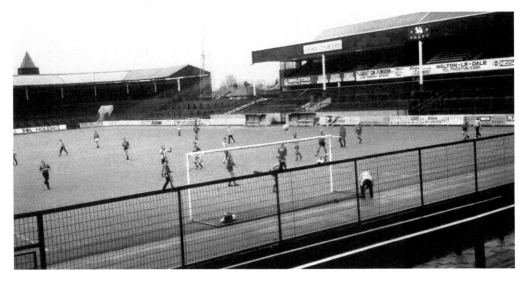

Preston North End had a new surface to play on when they began the 1986/87 season. The grass had been replaced by a synthetic surface supplied by En-Tout-Cas, thereafter known as a plastic pitch. They had ended the previous season having to apply for re-election having finished second from bottom in the entire Football League. The plastic pitch gave locals like these Goss employees in 1988 the chance to play on a Football League ground.

EIGHTIES REFLECTIONS

Taking the opportunity to reflect on the Preston of the 1980s, it is obvious there had been much change and that more was on the way. The town had certainly not stood still and having embraced the changes socially and environmentally it was prepared to move ever onwards. This defining decade certainly saw pioneering projects and progress made in a town that refused to linger in the past. Shopping and supermarkets, inns and taverns, trains, boats, buses and auto mobiles, and town centre changes are all worthy of reflection. The street sign displayed on the Market Square pointed the way forward in 1989.

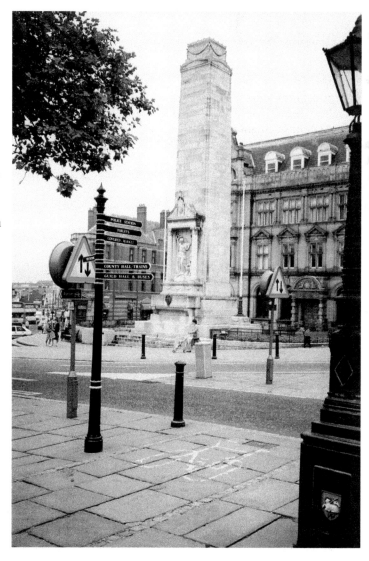

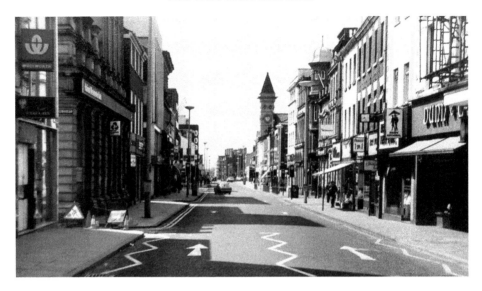

In Fishergate in 1982 it was strictly one-way traffic, as the arrows indicate. To the left is the NatWest Bank and further along the familiar ABC cinema sign can be seen. On a highway noted for its banks and building societies the Abbey National can be seen to the right next to Dunn & Co., who were a fashionable men's outfitters until the late 1980s. As for that NatWest bank, it would be knocked down within a decade and replaced by high-tech building more befitting the banking developments.

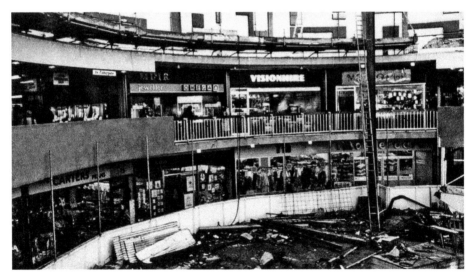

St George's Shopping Centre pictured in 1981 undergoing an ambitious refurbishment that was completed in April 1982, with the previously open-air venue becoming fully enclosed. It costs £5 million and the centre was transformed into a three-level mall linked by lifts and escalators, converging into the central rotunda. With attractive seating and background music, it was considered a worthwhile spend by then owners Legal & General as it attracted a weekly footfall of over 120,000 shoppers. A further upgrade was completed in 2000, costing £28 million.

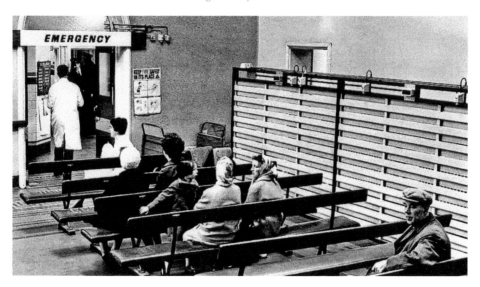

The waiting room at the Preston Royal Infirmary in Deepdale, pictured here, brings back memories of anxious hours spent waiting for news of loved ones. The medical services at the infirmary, opened in 1870, were gradually being phased out from 1983 with the new hospital at Fulwood becoming operational. Eventually in 1987 the last operation took place i, carried out by leading orthopaedic surgeon Mr Barry Case, who served the hospital for eighteen years. That day the last fifty patients were moved out of the infirmary to the new hospital.

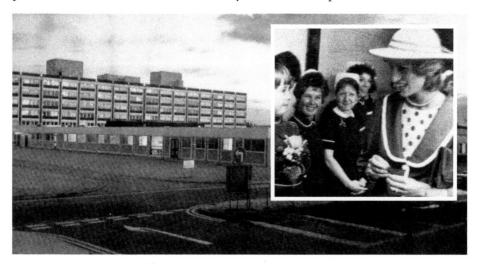

The Royal Preston Hospital, shown here in 1982, opened the doors to outpatients in early March 1981. A month later some 100 patients were admitted to the wards and two years later 600 beds were in use. The cost of the hospital was an estimated £45 million, enabling it to treat 100,000 outpatients, 32,000 admissions and 60,000 casualties a year. By March 1985 over 1,800 staff were employed in a complex that had a seven-storey ward block, twelve theatres and 7 miles of corridors. *Inset:* Princess Diana visited in June 1983 to officially open the hospital.

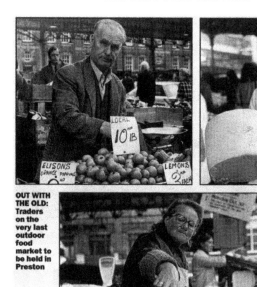

OUT WITH THE OLD: Traders on the very last outdoor food market to be held in Preston

For weather watchers the sub-zero temperatures of 1981 will bring back memories of schools being closed and Arctic conditions prevailing. A mid-December blizzard brought the heaviest snowfalls in Lancashire for almost twenty years. Trains and buses into and out of Preston were delayed and motorists struggled on the snow-covered roads and lanes. Once again in January 1984 blizzards swept across Lancashire with the snow ploughs called into action and power supplies cut as snow gathered on electricity pylons.

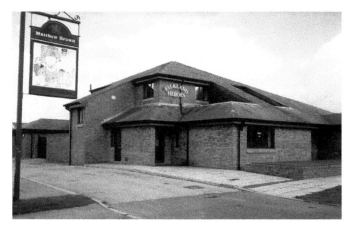

The Falkland Heroes was opened in 1983 to cater for the rapidly developing Tanterton village area of Preston. The theme throughout the inn was one of remembrance of the Falklands War in the South Atlantic between April and June 1982. A superb collection of mementoes and photographs lined the internal walls in tribute to the heroes. Unfortunately, the public house was destroyed by fire in December 2002 during a spate of vandalism.

Behind the public bar was a plaque that stated any visitor who was a Falklands veteran was entitled to a drink on the house. Among the first visitors in July 1983 were twenty sailors who were serving on HMS *Intrepid*, a vessel that had spent some hair-raising moments in the San Carlos waters during the conflict. After downing their pint of Matthew Brown ale they were off to the brewery to see the beer being brewed.

The final days beckoned for this row of shops on Fishergate in 1985 as work got underway to build the Debenhams shopping centre, demolition work having already started in the Butler Street area by the civil engineers of Sir Robert McAlpine. Plans were also in place to build new shops on the opposite side of the road on the old Loxham's car showroom site.

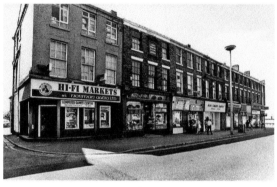

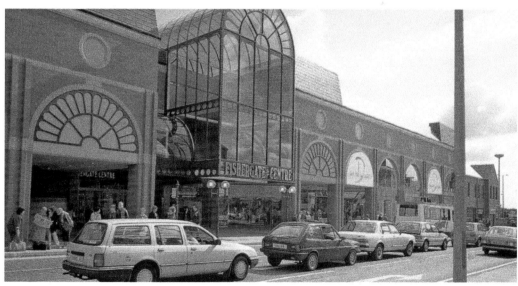

The Fishergate Centre, pictured here in 1987, had become a busy, bustling place with its striking canopied entrance on the main street. Over thirty-five retailers flourished after completion of the £16 million project and by 1988 the new owners of the site were Scottish Amicable. To the right a Zippy bus can be seen and was happy to pick you up or drop you off wherever you liked.

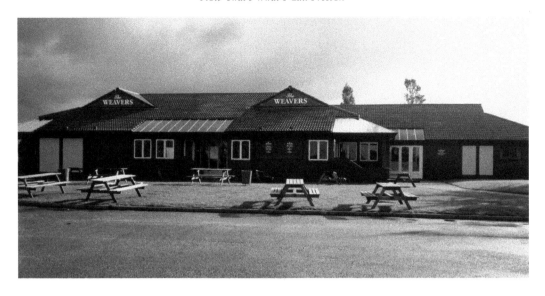

After the closure of Courtauld's 'Red Scar' Works in 1980 it was decided that a new public house, close to the site of former Courtauld's Social Club, should be named the Weavers in recognition of the textile workers of old. The inn, part of the Scottish & Newcastle Breweries Group, opened in September 1985 with seating for over 300 customers, and along with pub grub there was disco dancing. Despite enjoying early popularity amid the growth of the nearby Red Scar estate, the inn closed in 2012.

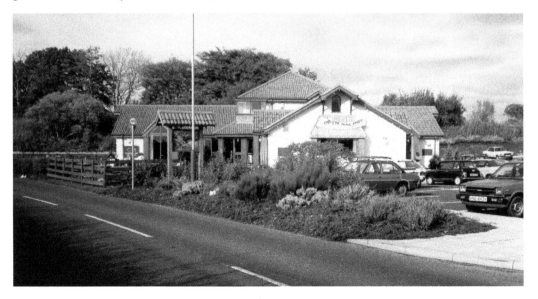

The Scottish & Newcastle Breweries once again provided a new inn in Preston. In May 1986 the Cotty Brook was opened on Lea Road, built by Lanley Bros of Chorley and costing £0.5 million. The pulling of the first pint was carried out by the mayor of Preston, Cllr Joan Ainscough, and residents on the newly built estates were happy to have their own local. This was another short-lived inn, closing in 2012 and being demolished.

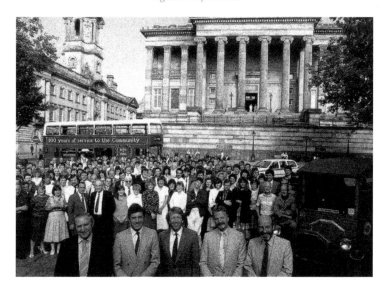

In October 1986 the staff of the Lancashire Evening Post made the short walk from their Fishergate home to the Market Place to mark 100 years of production of their popular daily newspaper. In 1886 George Toulmin, who owned the *Preston Guardian*, a twice-weekly newspaper, made a successful attempt at producing a daily newspaper. It caught on and had a thriving circulation far beyond the boundaries of Preston. Future generations of the Toulmin family ensured that Preston's premier newspaper continued to roll out of their Goss printing presses.

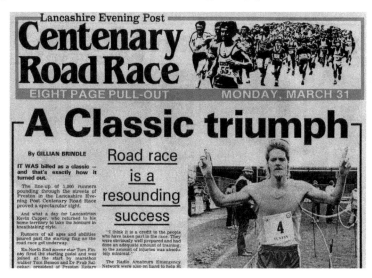

By 1986 the popularity of road running was at its height and the LEP held a 'Centenary Road Race' as part of their celebrations. Over 1,300 runners and thousands of spectators along the route made it a resounding success. The 10-mile race was run over a figure-of-eight course that ended at the Deepdale home of PNE and was won by Kevin Capper from Morecambe in just over forty-nine minutes. The first lady home was Maureen Hurst from Accrington.

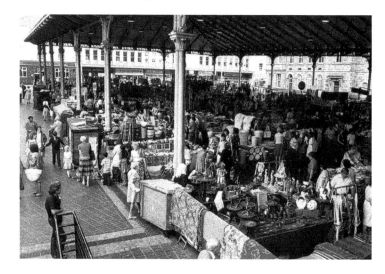

Despite the coming of the supermarkets the Covered Market was still a busy place in 1984, as seen here. Traders in fabrics, stalls with bric-a-brac, sellers of rugs and carpets and wicker baskets were all selling their wares. At the top of the picture in front of the St John's Shopping Arcade was the Rediffusion shop where you could rent a television. Next door the newsagent R. S. McColl was advertising cut-price cigarettes and on the opposite side of the arcade entrance, next to the Travel Centre, the latest fashions were on sale in Bobby's Boutique.

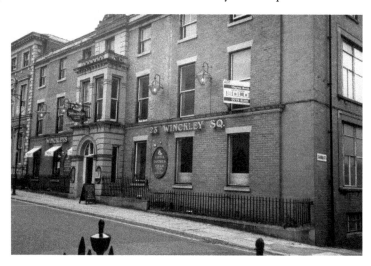

A few eyebrows were raised in August 1986 when Preston's latest public house/restaurant, Winckley's on the Square, was unveiled. The impressive building on the corner of Garden Street was originally the Convent of the Holy Child Jesus from 1875, a place devoted to the education of Roman Catholic girls. When secondary education changed in 1978 the pupils became part of Newman College, the building closing in 1981. The interior design retained many original features on different levels with an opulent look about the place – Boddingtons beer and a three-course meal for £12 with wine was on offer. Later known as the Olive Press, it is nowadays called Solita.

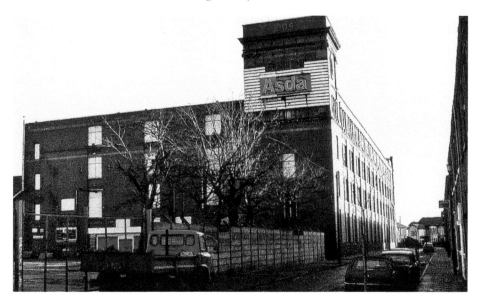

The former Cliff cotton mill in Dundonald Street, off New Hall Lane, opened in early 1906 and was eventually converted for shopping. It began life as Fame, became Gem in 1964 and eventually traded as Asda as the Associated Dairies group expanded. It was the shop where you could get a plump frozen turkey at Christmas in 1971 for 25*p* a lb. When Asda opened their Fulwood store in 1986 trading ceased in Dundonald Street and the mill was demolished a year later.

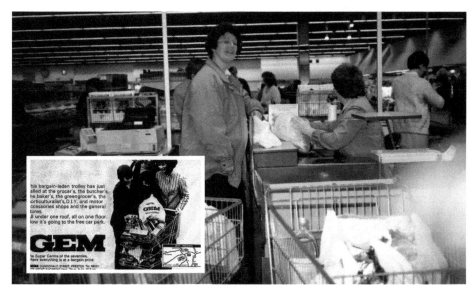

Time to fill your supermarket trolley at Asda in Fulwood in 1987. To tempt folk to leave the town centre and shop further afield free transport on Preston Corporation buses was on offer. The weekly shop for the family often necessitated two trolleys, many of which seemed to have a will of their own as you pushed them down the aisles. *Inset:* The GEM store had been popular.

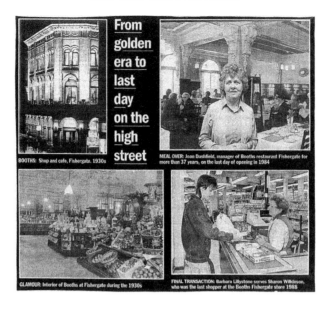

From golden era to last day on the high street

BOOTHS: Shop and cafe, Fishergate, 1930s

MEAL OVER: Joan Dashfield, manager of Booths restaurant Fishergate for more than 37 years, on the last day of opening in 1984

GLAMOUR: Interior of Booths at Fishergate during the 1930s

FINAL TRANSACTION: Barbara Lillystone serves Sharon Wilkinson, who was the last shopper at the Booths Fishergate store 1988

It was announced in late August 1988 that the Friargate premises of E. H. Booths, bought in 1867 by Edwin Henry Booth, the founder of the grocery chain, was to cease trading. At the time the company had twenty-two shops all over Lancashire and a bright future ahead for the business. The town centre grocery store had suffered a slump in trade, as had others such as Redman's and Liptons, with more shoppers heading to supermarkets on the outskirts of town. Until 1984 the Fishergate store had been famous for its first-floor café that was a meeting place for afternoon tea. Ornate ceilings, red carpets, starched tablecloths and silver service were all part of the ritual. Immediately after closure the ground-floor premises were leased to booksellers Waterstones.

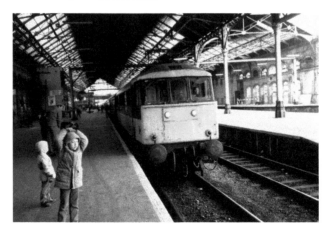

Gradually the high-powered Deltic diesel locomotives replaced steam locomotives on the London–Preston–Glasgow route and the service was upgraded again in 1973/74 following the electrification of the West Coast main line. Here on a cold February day in 1987 curious bystanders await the departure from Preston station of the regular intercity service using a Class 85 electric locomotive.

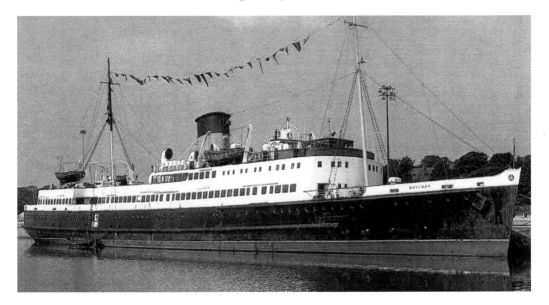

The TSS *Manxman* pictured in Preston Dock in 1983. It had arrived the previous September and there was talk of it becoming a floating museum and visitor centre. The vessel created much interest and spent some time as a floating nightclub. Alas, when the docks redevelopment got underway in earnest there was no place for it. Consequently, as the area developed into Riversway Docklands the vessel sailed away in November 1990.

New Hall Lane is a major gateway into Preston and the Hesketh Arms on New Hall Lane, situated opposite the Preston Cemetery gates, is a familiar site for motorway travellers heading into town. Known in the 1950s as the Cemetery Hotel, its origins can be traced back to the opening of the Preston Cemetery in 1855, with many a mourner drowning their sorrows within. The car park at the side on Blackpool Road, shown here in 1988, was once a popular bowling green.

Seen here in 1987, the Acregate Hotel on the corner of Acregate Lane dates from the late Victorian period with its impressive red-brick exterior. The name Acregate can be traced back to the D'Acre family of the thirteenth century. A Boddingtons house, it was visited by many punters making their way to the Preston Greyhound track down the lane, who enjoyed a pint here before they went for a flutter. Greyhound racing started in Preston in the mid-1930s with three meetings a week commonplace until 1988. A year later the bulldozers moved in at the track.

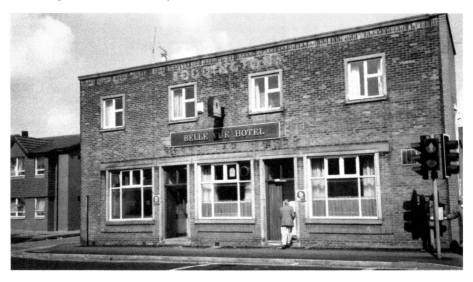

The modern-looking Belle Vue inn, pictured in 1987 when local welterweight boxer Peter Crook was the landlord, replaced an original hotel of the late 1860s and was a popular Boddingtons inn. In the 1970s there was a sign in the lounge telling customers 'English only to be used in conversation'. The brewery ordered the pub landlord to remove it in May 1975, an action that had Cllr Ernest Bunker and the Community Relations Council in agreement. It closed its doors in 2014 and is nowadays a grocery store called Maya Delikatesy.

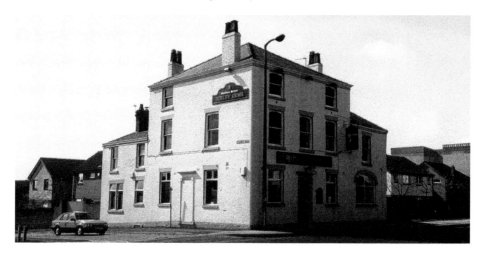

The Birley Arms on the corner of Fishwick Road, pictured in 1988, carries the name of the Birley family with Edmund Birley, Guild Mayor in 1882, a leading figure in the textile industry and associated with the Fishwick Mills. The inn dates back to 1853 and was completely gutted by a fire in which a girl tragically died in 1885. It became a popular place with cinemagoers who visited the Plaza cinema across the road, which opened in 1932 and closed in 1964 and is now a petrol station. The last drinks at the pub were served in 2005 with the premises converted into solicitors offices.

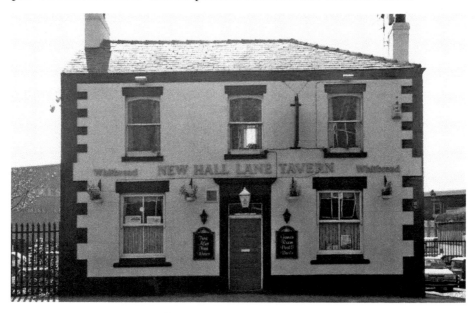

The aptly named New Hall Lane Tavern pictured in 1987. To the rear the Preston Farmers premises can be seen, which was refurbished after the devastating fire of February 1970 when flames destroyed their four-storey mill in a £1 million blaze. The inn can be traced back to 1865 and in the days when it was surrounded by rows of terraced homes it had the General Codrington and the Gibralter Inn as near neighbours. It was closed in 2001 and a Lidl store and a bingo hall now occupy the area.

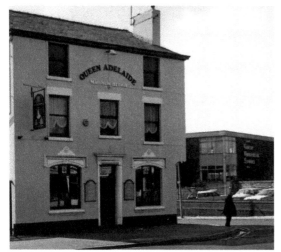

The Queen Adelaide situated at the corner of Adelaide Street was opened in 1839. When pictured in 1989 the inn was the first public house on New Hall Lane from London Road following the demolition of the Rosebud. In bygone days it had been the seventh public house on New Hall Lane from London Road. This former Matthew Brown pub closed in 2000 and a new building, the ALAM Store, occupies the site. To the right of the picture is the Great Universal Stores that fronted onto London Road and was opened in 1968.

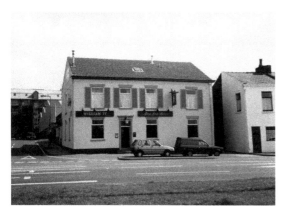

If in 1989 you had taken the short walk from the Queen Adelaide down Adelaide Street and Primrose Hill, you would have come upon the William IV public house on London Road. A popular local, it dates from 1832 a time when William IV (1830–37) was the ruling monarch and Adelaide was his queen. With industrial units to its rear it survived changes in the area until closing in 2005. In 2016 it opened as the Mumu Steakhouse.

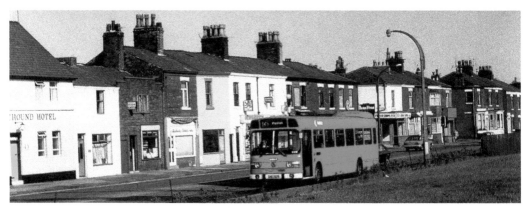

This London Road scene of the 1980s shows the rebuilt Greyhound Hotel, which was the scene of the tragedy of November 1960 when four people were killed when the walls collapsed during renovation work. Fast food was yet to arrive, although there was a traditional fish and chip shop next to the Walmsley bakers shop and a newsagents/off-licence advertising Lion Ales. A Ribble bus waits by the grass verge where once a row of terraced homes stood.

Certainly it seemed difficult to keep a Ribble bus out of the picture as a double-decker emerges from Ribbleton Lane. The County Arms, at the junction of Deepdale Road and Ribbleton Lane, was a popular local in 1989 when this picture was taken. The premises closed for a short time in 1978 to carry out structural alterations. The popular landlord of this inn from *c.* 1968 was Brian Atkinson. The inn closed in 2006 and was recently demolished.

The Fylde Street roundabout viewed from the bottom of Friargate in 1988. On the corner of Adelphi Street stands the Adelphi Hotel, situated there since *c.* 1838, and behind it the tower of Henry Shutt's corn mill. To the right on the corner of Moor Lane the TSB bank is open for business. A popular haunt for students of the university, the Adelphi thrives in its location.

Ringway view during rush hour in 1988 with a Zippy bus heading towards Friargate. The Queensway furniture store, nowadays the Greyfriars public house, can be seen to the left. On the skyline centrally is the Preston police station building – occupied from 1973 on Lawson Street – and to its right is the Marshall House office block.

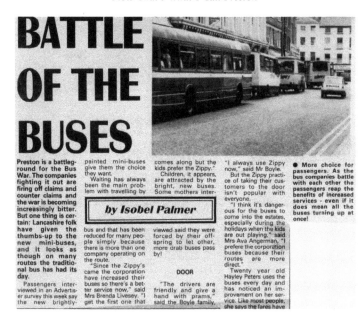

BATTLE OF THE BUSES

by Isobel Palmer

Preston is a battleground for the Bus War. The companies fighting it out are firing off claims and counter claims and the war is becoming increasingly bitter. But one thing is certain: Lancashire folk have given the thumbs-up to the new mini-buses, and it looks as though on many routes the traditional bus has had its day.

Passengers interviewed in an Advertiser survey this week say the new brightly-painted mini-buses give them the choice they want.

Waiting has always been the main problem with travelling by bus and that has been reduced for many people simply because there is more than one company operating on the route.

"Since the Zippy's came the corporation have increased their buses so there's a better service now," said Mrs Brenda Livesey. "I get the first one that comes along but the kids prefer the Zippy."

Children, it appears, are attracted by the bright, new buses. Some mothers interviewed said they were forced by their offspring to let other, more drab buses pass by!

DOOR

"The drivers are friendly and give a hand with prams," said the Boyle family.

"I always use Zippy now," said Mr Boyle.

But the Zippy practice of taking their customers to the door isn't popular with everyone.

"I think it's dangerous for the buses to come into the estates, especially during the holidays when the kids are out playing," said Mrs Ava Angerman, "I prefere the corporation buses because their routes are more direct."

Twenty year old Hayley Peters uses the buses every day and has noticed an improvement on her service. Like most people, she says the fares have

● More choice for passengers. As the bus companies battle with each other the passengers reap the benefits of increased services - even if it does mean all the buses turning up at once!

The 'Battle of the Buses' was the headline news in July 1987 in the pages of the *Preston Advertiser*. The arrival of the brightly coloured Zippy buses, introduced as a subsidary company by Ribble Motors with a policy of picking up and dropping off customers at convenient points, was seen as a threat to local buses. Preston Bus Co. responded by increasing its own minibus fleet to over fifty and within a couple of years the competition was defeated. Preston Bus Co. was sold by the town council in 1993 to its employees and they in turn sold out to Rotala.

There was plenty of traffic too at Lane Ends in 1988, as this picture shows. The Lane Ends Hotel, a popular Boddingtons house at the time, was originally built around 1855. To the left on Blackpool Road is the Cleaning Centre with washing machines and dryers aplenty to do your weekly washing. To the right on Woodplumpton Lane is the E. H. Booths store, a handy location to get your groceries.

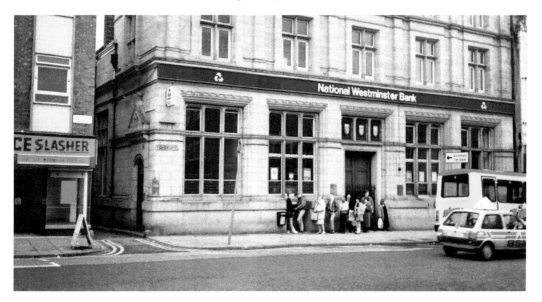

The National Westminster Bank in 1988 with a queue waiting for the cash machine – note the Zippy bus and the British School of Motoring car to the right. The bank was to hit the headlines in mid-September 1988 when an armed robbery took place with over sixty staff held hostage. When NatWest moved to newly built premises in 1991 it became the Wall Street public house and is now called the Fishers.

Across the road the Miller Arcade had returned to its Victorian splendour by 1988 and its owners, P&O Properties, had an interesting selection of shop tenants. Fashion store Mahogany and Euroclean were either side of the Church Street entrance with Menzies, Rafters hairdressers, the Outdoor Camping shop, M & N Textiles and Cameo gifts among the other traders. *Inset:* The Wine Store and the popular Emily's Pantry can be seen from the Market Square.

Life could seem quite simple in 1989; after all you could buy a bargain pair of shoes from Curtess on the corner of Orchard Street, drink in the Market Tavern (a Matthew Brown pub in those days) and dance the night away in the lavish 'Squires' nightclub with the 'Snoopys' disco, which opened in 1979.

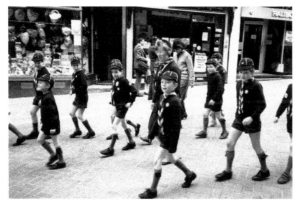

Cub Scouts from Ingol make their way down Orchard Street in the St George's Day parade of 1988. Scouting in Preston was established in 1910 and by 1916 there were twenty troops in Preston with over 500 scouts. The enthusiasm for scouting developed throughout the town with beavers, brownies, guides and scouts groups all flourishing.

On Church Street the Bull & Royal was popular once more in 1989 and alongside it is the Central Conservative Club where the Discount Book Co. once prospered. The Conservative Party had slipped from power in the Town Hall in May 1980 with Labour keeping a strong grip throughout the next decade. To the left is Preston Parish Church before its Minster days arrived. The vicar of Preston from 1980 until 1991 was Revd Michael Higgins, the fifty-eighth vicar of Preston. He headed the Team Ministry that linked the town centre's Anglican churches.

Further along Church Street, viewed from Pole Street, things were looking somewhat neglected in 1989, a sign of the shift in the shopping areas of the town. On the corner of Pole Street the 'Real McCoy' was offering tasty burgers to take away. Having relocated from across the road, it was next door to a Happy Haddock fish and chip shop, part of a chain of chippy's that prospered in the town from 1966.

A view of the Harris Museum, Art Gallery and Library in 1987 at which time they held an exhibition celebrating 100 years of the St John's Ambulance Brigade. Formally opened in late October 1893, the magnificent neoclassical building had undergoing some refurbishment work with new galleries and displays being created. In December 1986 a new gallery entitled 'The Story of Preston' had been created tracing the development of the town, delving back some 12,000 years. Supported by volunteers known as 'Friends of the Harris', it had become one of the North West's busiest museum.

The Obelisk on the Market Square was originally constructed and erected in 1782. It was removed in 1853 and for 126 years stood at Hollowforth Hall in Woodplumpton. In 1979 it was returned to the Market Square with the consent of its owner, Mr Edward Nicholson, as part of the Octo-Centenary celebrations marking the date of the Preston royal charter back in 1179. It was unveiled by HM Elizabeth II.

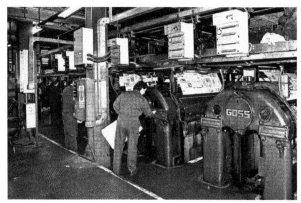

In the first week of February 1989 the *Lancashire Evening Post* printed the final edition at their Fishergate premises as they prepared to move to a custom-built £28 million plant on Eastway, Fulwood. Mr Michael Toulmin, a descendant of George Toulmin, the founder of the LEP in 1886, was on hand to press the button that set the Goss presses in motion for the last time.

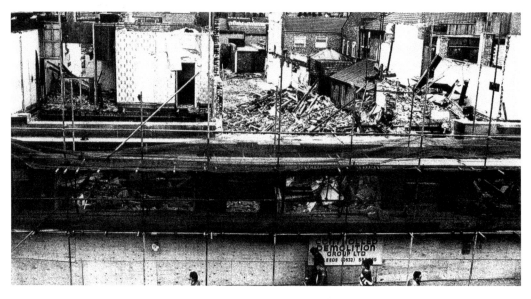

Within a year the *Lancashire Evening Post* premises, which stretched back into Castle Yard, were being knocked down. The yawning gap on Fishergate was eventually filled with a double-fronted Top Shop/Top Man clothing store.

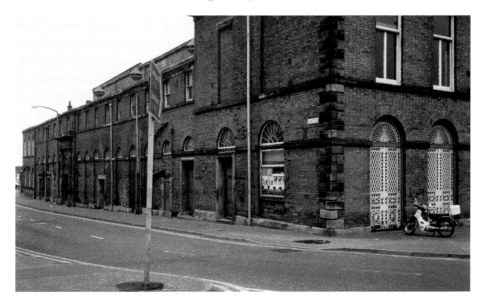

Towards the end of December 1989 it was announced that the Public Hall, closed in 1973, would, after years of negotiations, have a stay of execution. With plans drawn up for the link between the Penwortham Bypass and the inner ring road, it was announced that the front of the building would be preserved with the rear two-thirds being demolished. The historical frontage of the old Corn Exchange was converted into a public house.

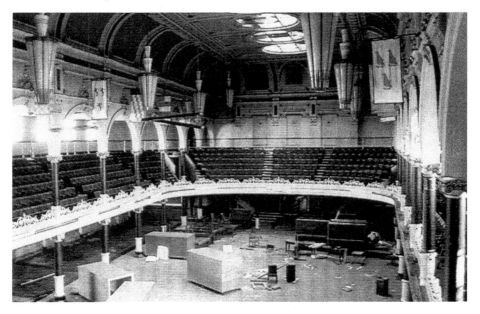

A glimpse inside the Public Hall shortly before its fate was sealed shows the impressive architecture that had made the building such a favourite place for grand balls, concerts and civic occasions. From a Corn Exchange of 1824 through decades of grandeur as a Public Hall, the truncated structure became a popular public house.

In this early morning view of the Market Square in 1987 the sea and army cadets prepare for the Remembrance Day parade. On Cheapside the Pizza Hut has arrived in town next to the Schrieber furnishings store, which has the Early Learning Centre as a neighbour, along with shoe supplying rivals Stead & Simpson and Barretts.

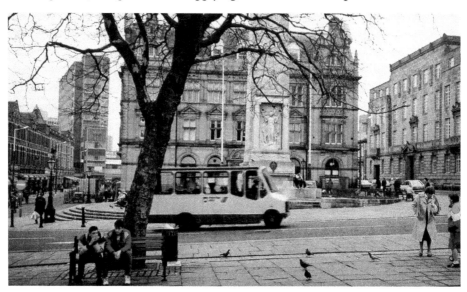

The Market Square scene in 1987 at a time when the General Post Office was about to undergo a £500,000 upgrade, including an Edwardian-style entrance being built on the Birley Street side. The building, constructed in 1903, was still being used by 600,000 customers every year. To the left down Market Street the tall tower known as Lowthian House can be seen, a retail and office block on the old Starchhouse Square site with the Lancastria Co-op occupying the shop premises from 1976. Nowadays it is where Iceland trade. The GPO vacated its grand premises in November 2002 and they are now being made into the Shankly Hotel.

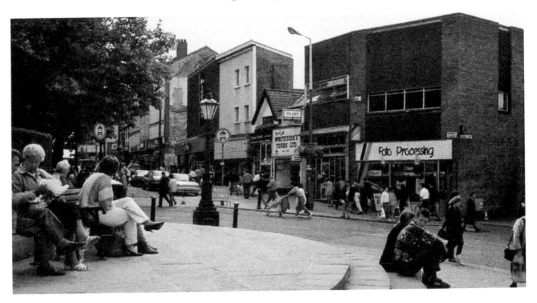

A busy Cheapside in 1988 as shoppers take a well-earned break on the seats beside the Cenotaph. On the Anchor Court corner the Foto Processing shop is busy in the days before the digital photo revolution. Alongside are Sheldons hairdressers and travel agents Whiteside Tours, who stand next to Preston's longest-surviving shop premises, which is occupied by Thomas Yates the jewellers.

Shoppers enter the zebra crossing on Friargate in 1988 as a Zippy bus heads to the central bus station and a Preston Corporation bus heads out of town. The former Martin's Bank on the corner of Market Street had become a Barclays Bank in 1969 following a takeover. Halfords were still trading on Friargate and further down Curry's and DER had colour televisions on offer. Specsavers had arrived in town offering Preston folk better vision for the future.

ACKNOWLEDGEMENTS

I must acknowledge the help given to me by the staff of the Harris Community Library in Preston, who willingly assist as I delve into their archives. Their extensive records make my research that much easier.

My appreciation also goes to the newspaper reporters of the past who, in chronicling the events of their days, made this book possible. The *Lancashire Post*, *Preston Citizen*, *Preston Herald*, *Preston Chronicle* and *Preston Pilot* are all sources of valuable information.

I would like to thank the *Lancashire Post* for permission to use images that are nowadays stored in the Preston Digital Archive. Also, my thanks go to Richard H. Parker, the creator of the PDA, for use of images from that source and to Mike Hill, Communities Editor of the *Lancashire Post*, who is ever helpful in my research.

My thanks also go to Pat Crook for checking my manuscript and putting her literary skills at my disposal once again in a cheerful manner.